SOMETHING
FISHY
THIS WAY
COMES

The Artwork of Ray Troll

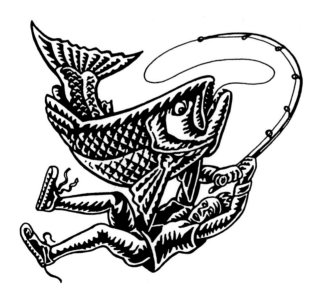

SASQUATCH BOOKS
SEATTLE

For Skip and Marie Jensen and the fine crew at
Post Industrial Press, masters of the well-honed squeegee.

Printed in China
Published by Sasquatch Books
Distributed by PGW/Perseus
15 14 13 12 11 10 9 8 7 6 5 4 3 2 1

Cover and interior illustrations: Ray Troll
Interior design: Kate Thompson
Interior composition: Kate Thompson and Liza Brice-Dahmen

Library of Congress Cataloging-in-Publication Data is available.

ISBN-10: 1-57061-682-5
ISBN-13: 978-1-57061-682-2

Sasquatch Books
119 South Main Street, Suite 400
Seattle, WA 98104
(206) 467-4300
www.sasquatchbooks.com
custserv@sasquatchbooks.com

FOREWORD

by JOHN STRALEY

If there were such a thing, Ray Troll would be the Artist Laureate of
Hallucinatory Fish Images.

It seems natural to think of him that way now, but it wasn't always so.
Ray started life as an Air Force Brat, moving around the world at random
intervals. He saw the wide-open spaces of the Midwest and the gothic
churches of Europe. He was part of a fractious brood of opinionated and
talented siblings. He was an Art Nerd early on, drawing soldiers in the
margins of his textbooks and entire detailed battle scenes on the inside of
his Pee-Chee folder. He went to art school and evolved through a brief and
probably ill-advised performance-art, black-beret-and-French-cigarette
period. Through the seventies, eighties, and nineties he always wanted to
be hip, but in those decades life did not deal him the cards. Ray was dealt
the brainiac lover-of-arcane-information, big-glasses-wearing, bald-too-
soon, bad-pun-loving hand—aces over eights—full-on nerd.

But lucky for him that he lived long enough to ride the karmic wheel
into the twenty-first century, where being a fish-loving raconteur of the
Paleolithic and a stone-cold art nerd was cool.

Go figure.

He is a prodigious worker. This is a Ketchikan trait. While
you can laze about in a coffee shop bullshitting with other
artists about grant applications, you will soon starve
to death in Ketchikan and no one will much notice
. . . or care. Ray worked in the fish houses and on
the waterfront. It was here in the steam hiss

and stink of the Ketchikan wharfs that he was captivated by the irides-
cent salmon sliding toward the glinting knifes along the slime line. What
could be more lovely than the bullet shape of a Coho or the muscular bulk
of a king salmon, fish as lithe and lovely as a bauble of quicksilver? If form
follows function and ontology really does replicate morphology, what is
more worthy of consideration than the mind and body of a fish? The art
nerd had found his muse, he had long since developed the work ethic . . .
now he just needed the perfect forum in which to show and sell his work.

There is some dispute as to who came up with the T-shirt first. Some
say it was handmade by Eastern European coal miners around the turn of
the last century. Some say that in the 1920s the U.S. Navy began making
cheap shirts for sailors working in the engine rooms who needed to
remove their uniforms to keep them clean.

But by the 1950s, the T-shirt had become the garment of the working-
class sex god. Think of Marlon Brando bellowing up to the balcony in *A
Street Car Named Desire*. Think of James Dean in *Rebel Without a Cause*,
rolling a cold milk bottle across his forehead. The war and the G.I. Bill had
brought about an new egalitarianism, informal dress became the norm—
at home at least—and the T-shirt was the new standard for leisure wear.

But here was Ray Troll, laboring in the fish house. His art-nerd brain
was feverish to make something beautiful and feverish to share his new-
found love of the aquatic. His choice of the T-shirt was genius. Rather than
have a few people wander into a gallery where even fewer would buy the
paintings, Ray would make fine art that could walk around in the world on

the front of people's chests. Like his puns, his images are just slightly crass, erotic, and erudite. This was a perfect marriage. The informal naughtiness of the T-shirt was suited to the naughtiness of the pun. Oh yes . . . puns are naughty—that's why we groan louder for the good ones. The pun is the rebel without a cause of literature.

It is on the chests of the world that Ray Troll created his masterworks. His detailed and anatomically correct images of sea creatures found the perfect pairing of medium and message. For it doesn't take much of a plunge into the collective unconscious to find that fishing—the capturing of the wild and beautiful—is itself erotic in nature. Why else would so many wives buy these T-shirts for their husbands?

On the shirts of the world, Ray Troll's fish walk among us. They shimmer and eddy, they lunge up from the depths spouting their inexplicable puns. They are common and extraordinary. They are well mannered but subversively erotic. Ray Troll's fish are goddesses . . . and everyman.

This book is like a giant aquarium where you can see them all at once.

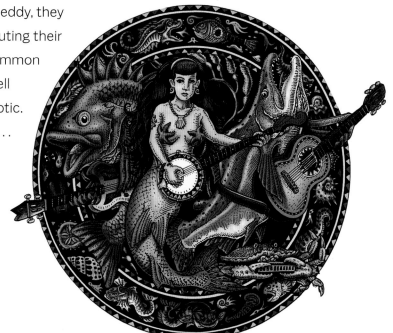

BUREAUCRATS OF THE DEEP

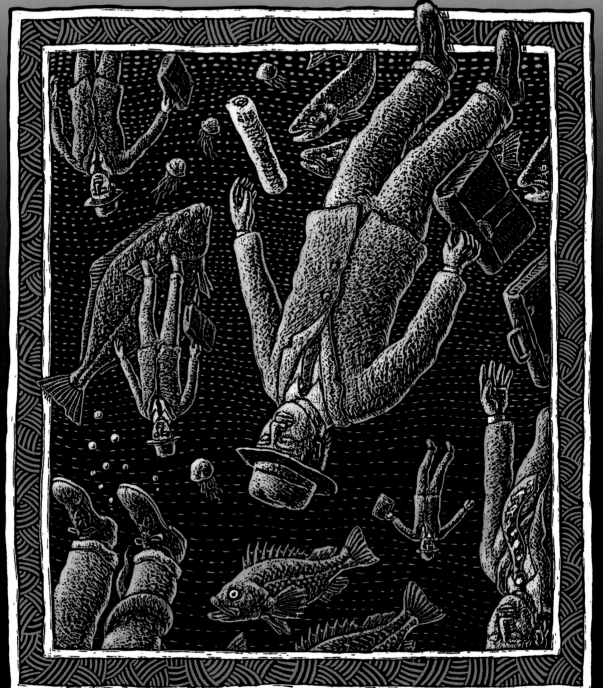

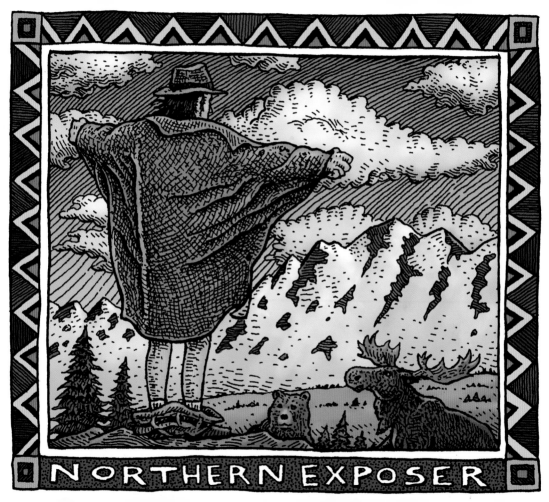

NORTHERN EXPOSER

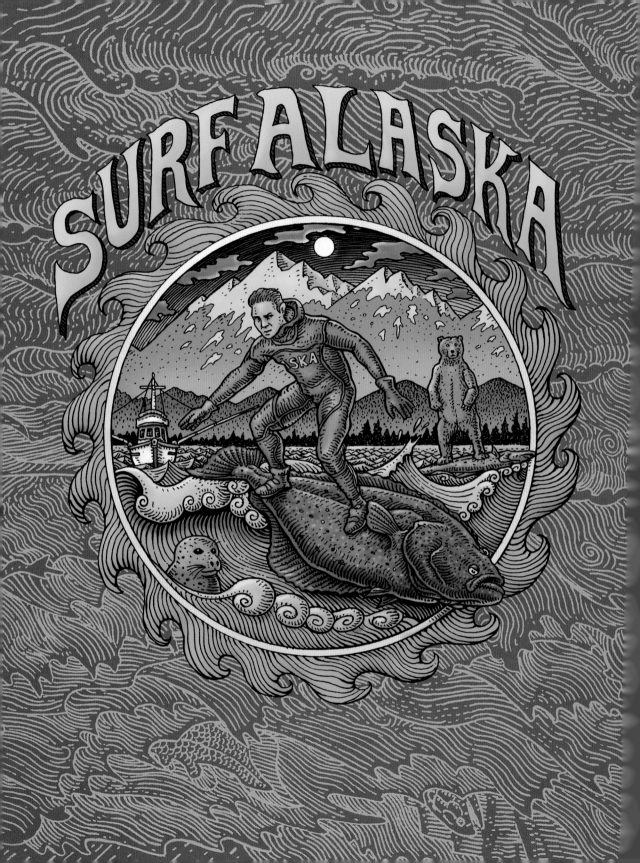

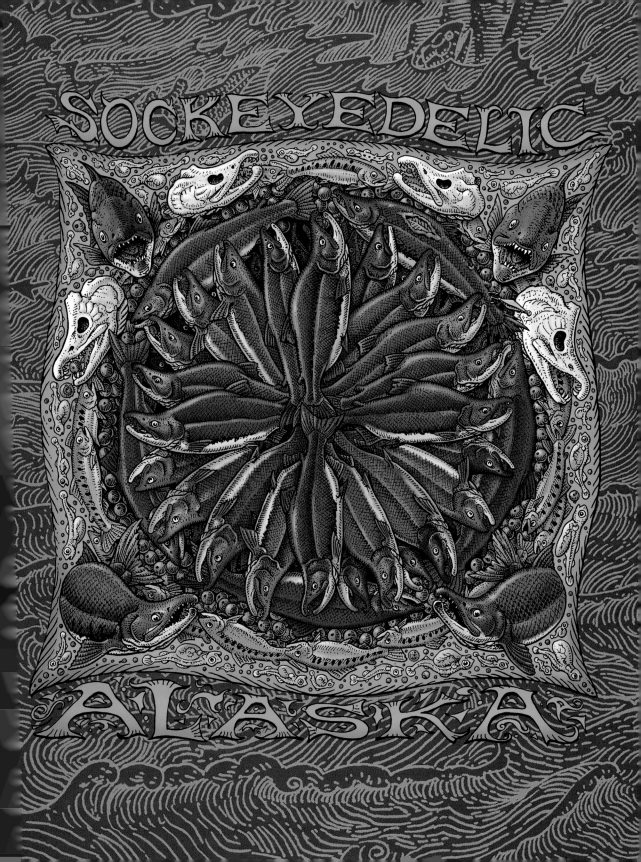

ALASKA

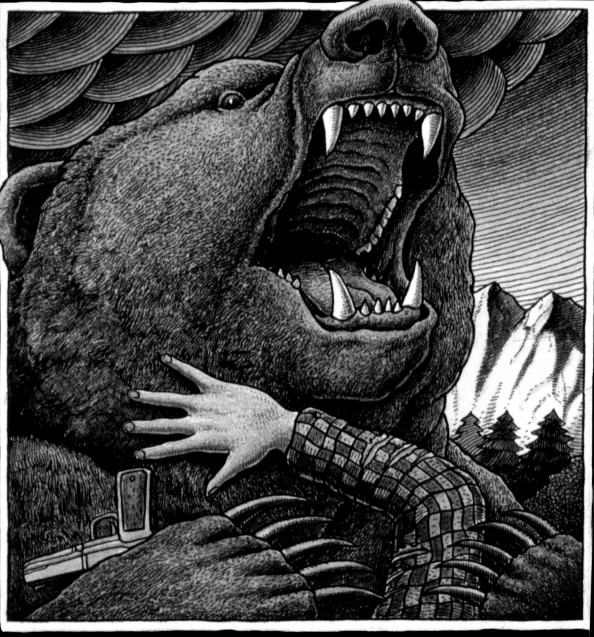

the last great adventure

A Kodiak moment...

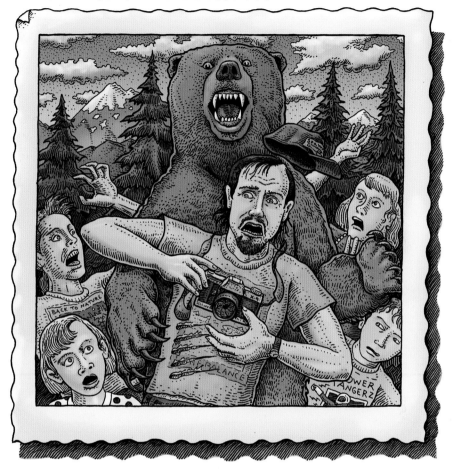

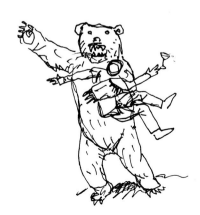

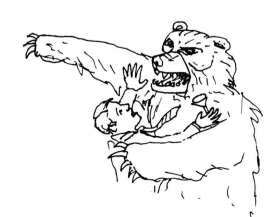

SOUTHEAST

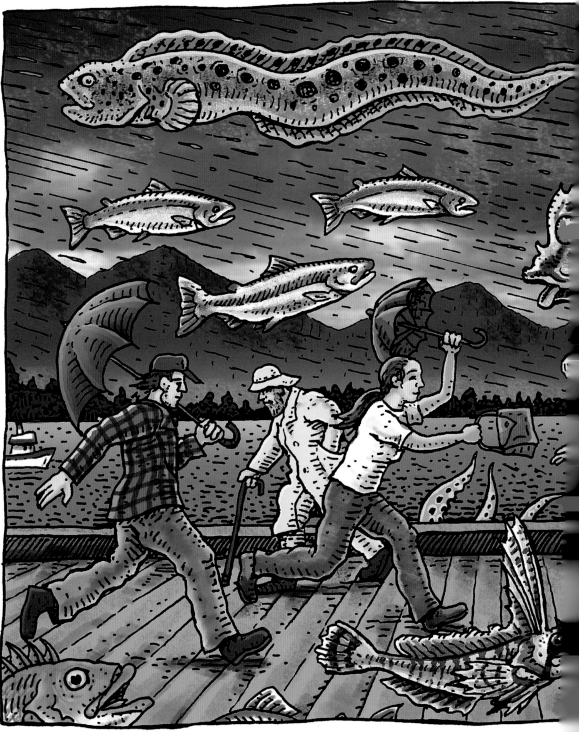

AS CLOSE AS YOU CAN GET TO ACTUALLY LIVING UNDERWATER

ALASKA

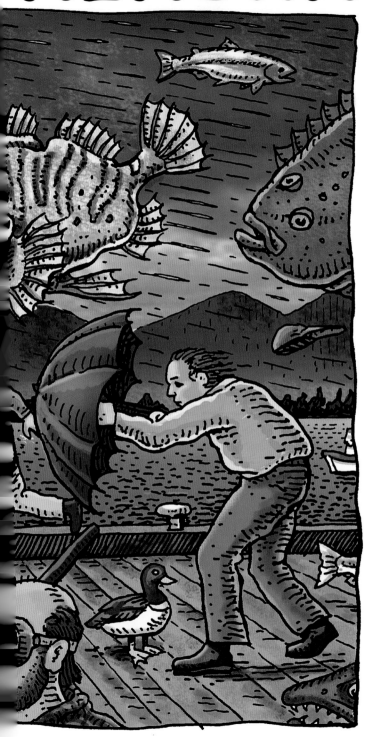

100 NAMES FOR RAIN

DRIZZLE - RIVERS OF - POUNDING - MONSOON - SHOWERS - RAIN OF BLOOD - DRIVING - SOOTHING - GOD RAIN - INCESSANT - MIX CO.

HARD RAIN · DULL GREY TEARS OF

SOFT RAIN · POURING / SCATTERED TEARS OF

FOGGY

CATS'N DOGS · CLEANSING · OCCASIONAL HEAVEN

SPRINKLE / CYCLE OF · PERPETUAL · INVIGORATING

BUCKETS OF / WET STUFF

HYDROLOGICAL CYCLE · NEVERENDING

RAIN IN MY HEART · POOLING · FRIGGIN' LIFE /

SLUSHY · VAPOROUS · PERIODIC GIVING

MIXED WITH HAIL · INCHES OF · INTERMITTANT · FREQUENT

DEEP IN MY SOUL

WHIPPING ON THE ROOFTOP · DEEP IN THE BRAIN

BLINDING — IN THE GUTTERS · RHYTHM OF THE /

LIGHT RAIN · GODDAM · RHYTHM OF THE /

BLUE BLUE /

PELTING · APOCALYPTIC /

OF DEATH · CATACLYSM /

DRENCHING · NON STOP · OF SORROW /

TORRENTIAL · ENDLESS · OF AGONY · WATER /

THE A WORD · OF 40 DAYS · SADNESS OF

RIBBONS OF · 40 NIGHTS · MEMORY LIFE /

SINGING IN THE / CHANCE OF · TICKLING SAD—

METAPHORIC / LIKELIHOOD OF · HOWLING /

PRECIPITATION · MISERABLE · PURIFYING /

THUNDER AND / GODFORSAKEN · BLESSED INTO EACH

HORRENDOUS / FORLORN · LIFE MUST FALL /

DELUGE / SHEETS / BONE SOAKING · FOGGY /

WATER · DEPRESSING · SOGGY · DAMPENING /

REJUVENATING

CUTTHROAT BUSINESSMEN

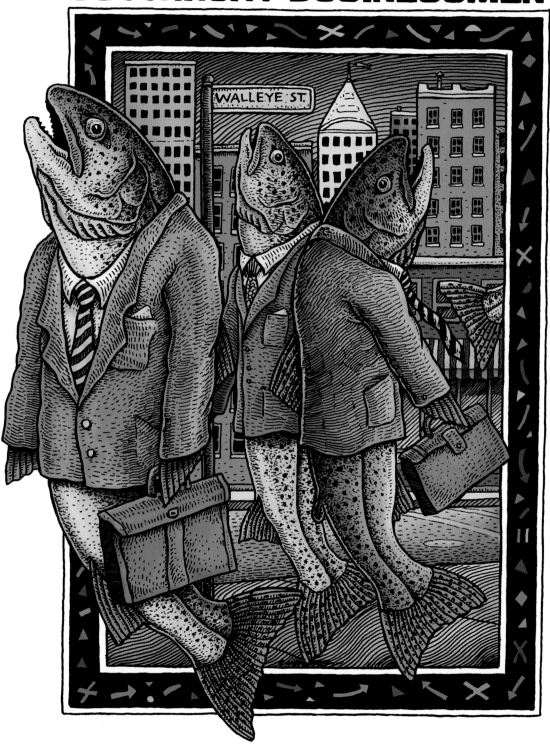

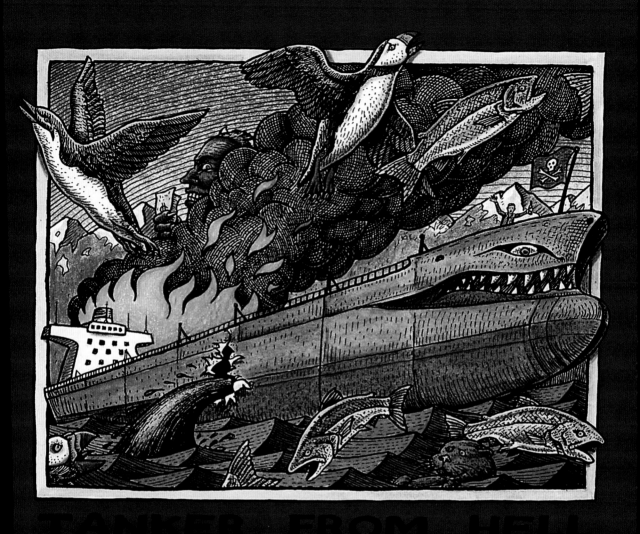

TANKER · FROM · HELL

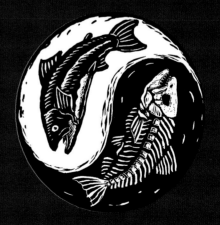

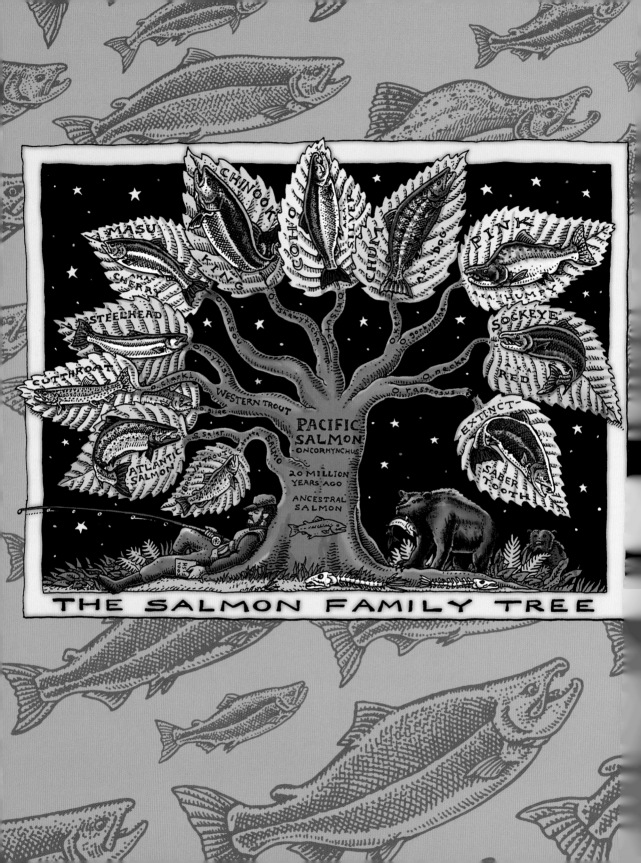

THE SALMON FAMILY TREE

TOTALLY IN·SEINE

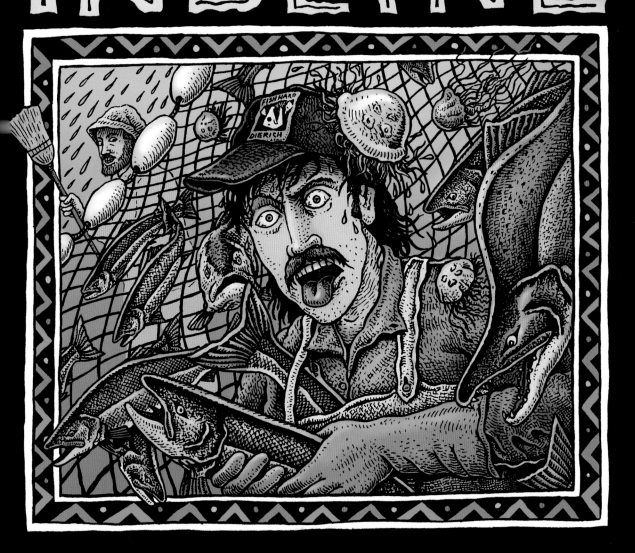

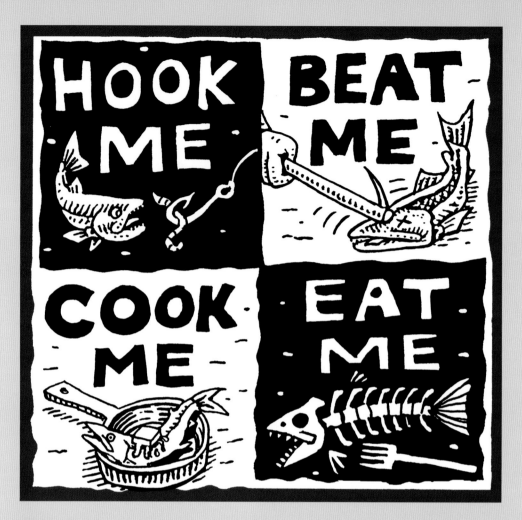

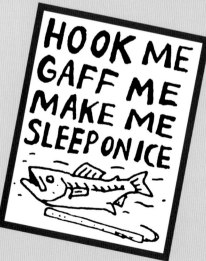

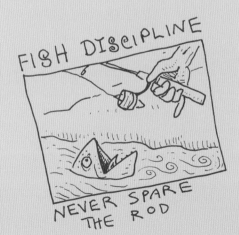

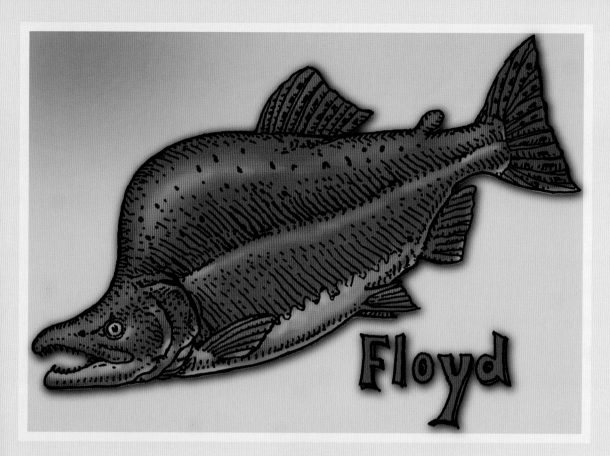

Floyd

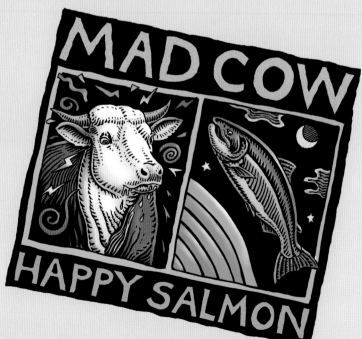

MAD COW

HAPPY SALMON

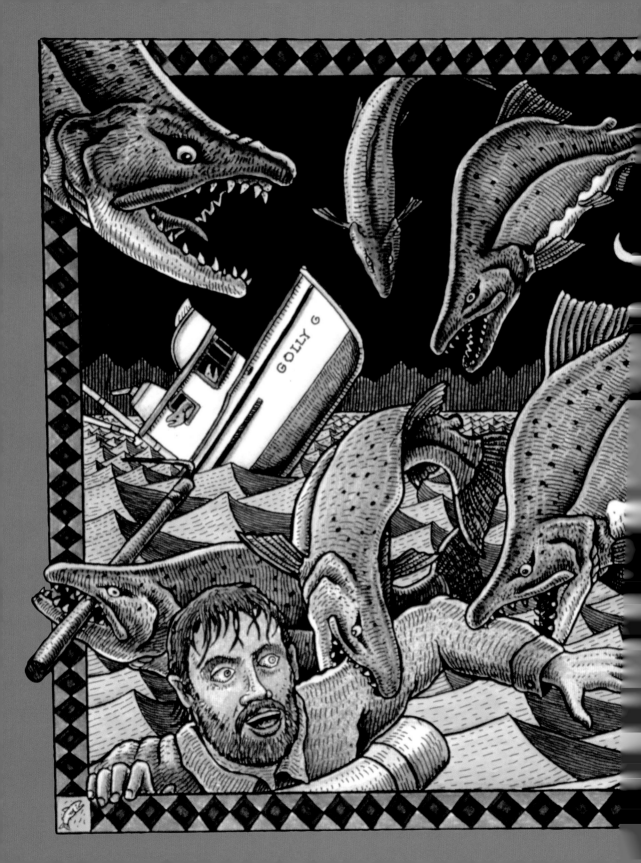

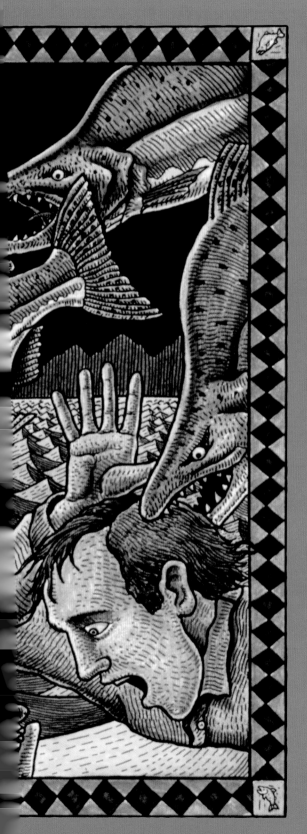

REVENGE
OF THE
HUMPIES

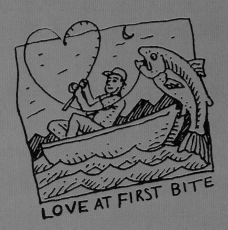

LOVE AT FIRST BITE

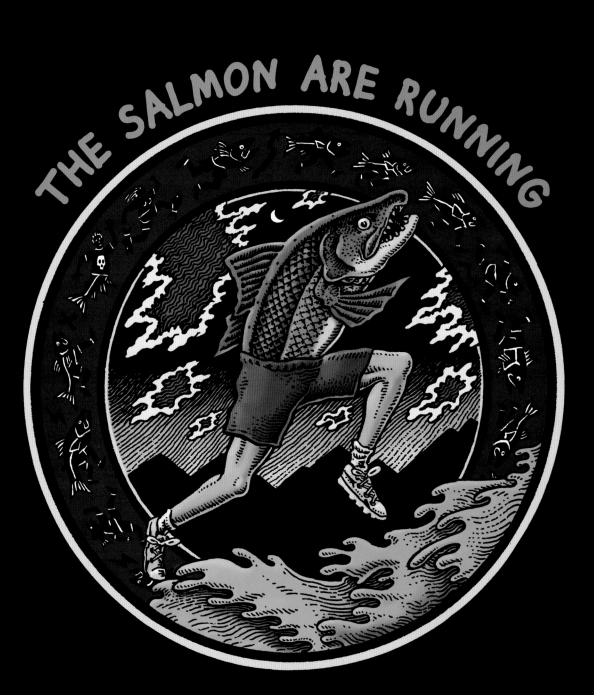

THE SALMON ARE RUNNING

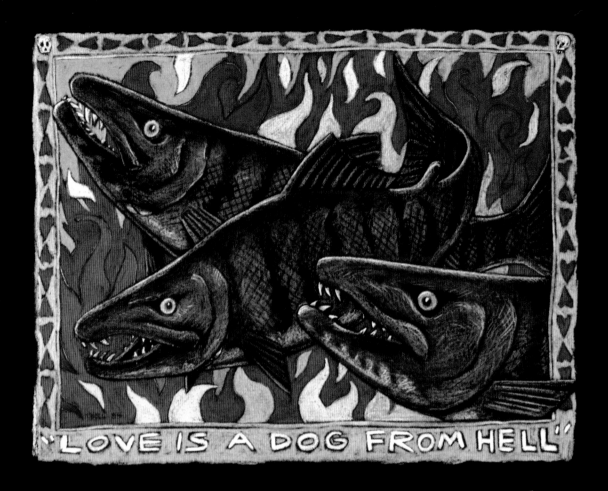

"LOVE IS A DOG FROM HELL"

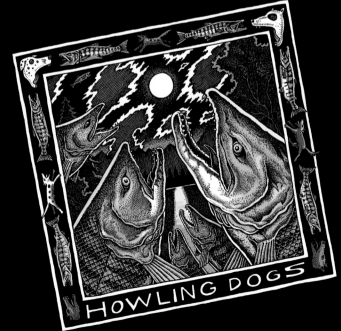

HOWLING DOGS

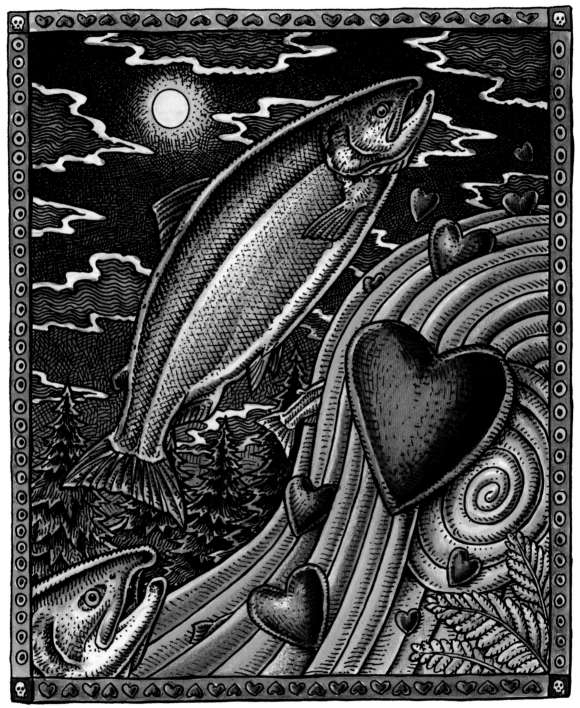

SALMON: THE FISH THAT DIES FOR LOVE

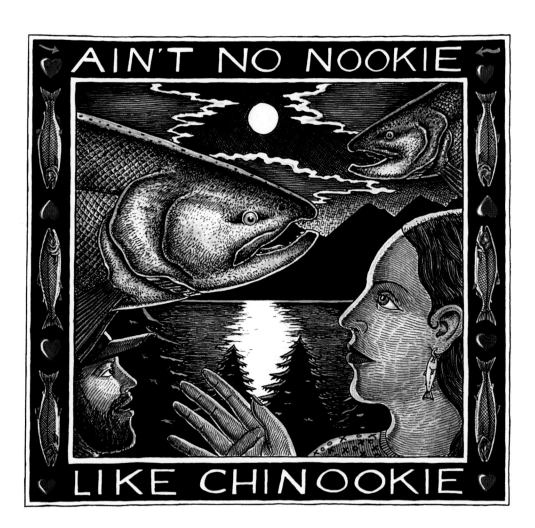

AIN'T NO NOOKIE

LIKE CHINOOKIE

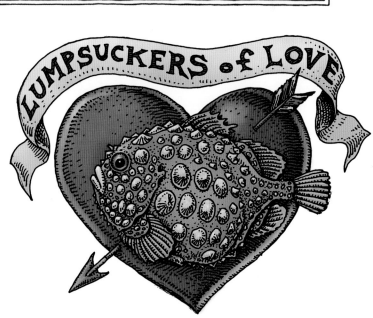

LUMPSUCKERS of LOVE

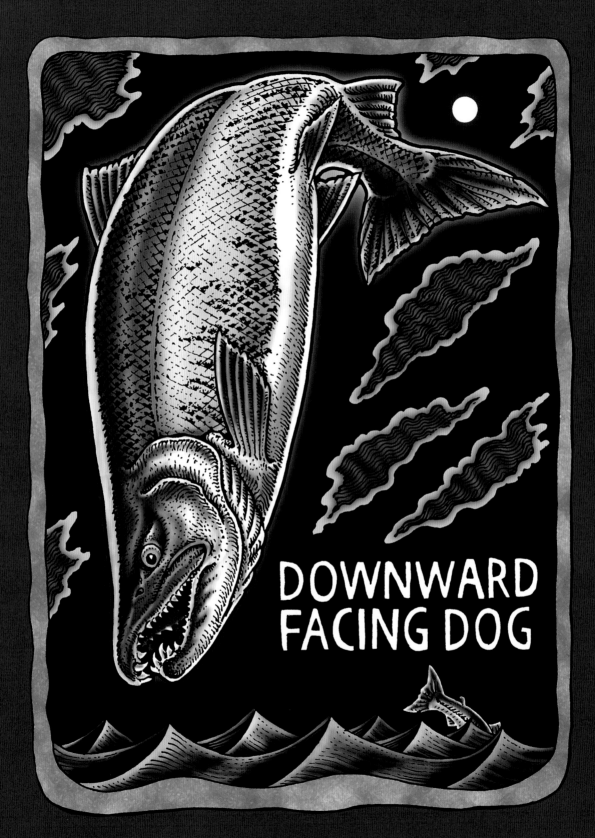

DOWNWARD
FACING DOG

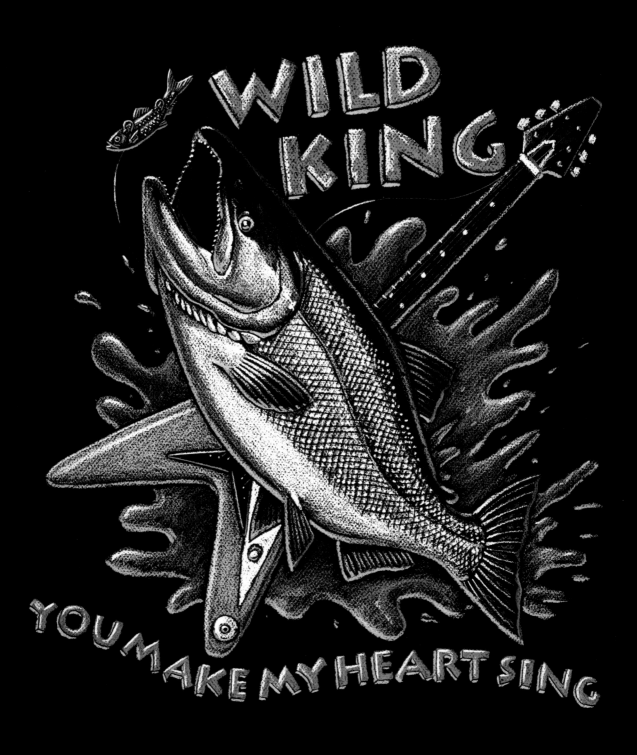

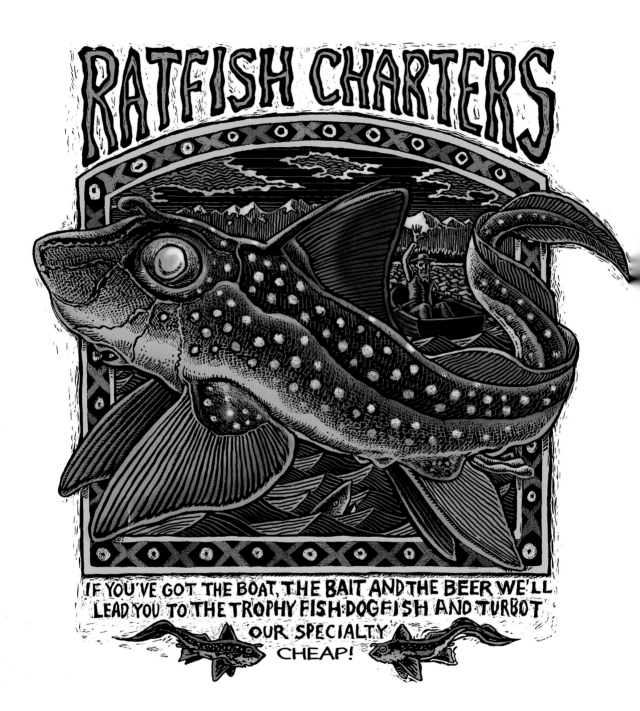

SALMON WARS

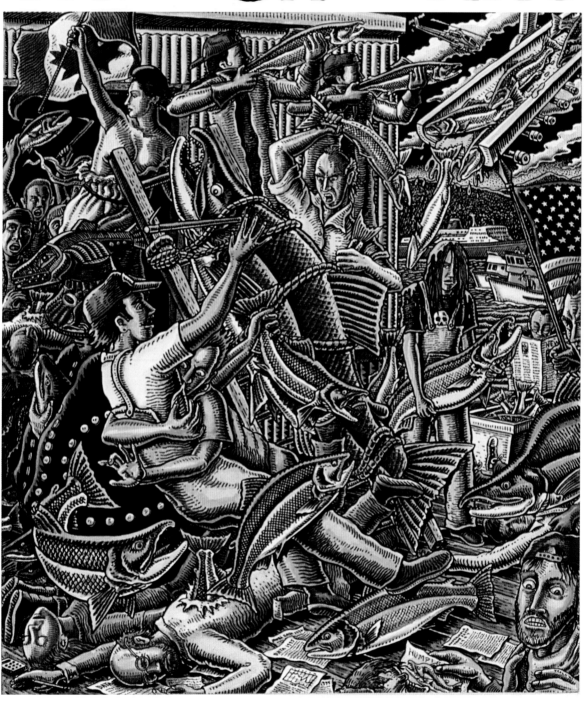

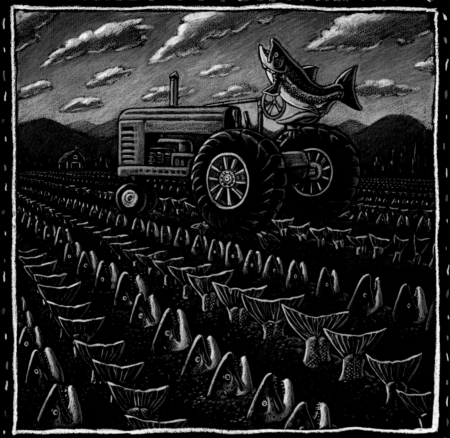

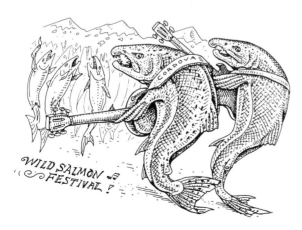

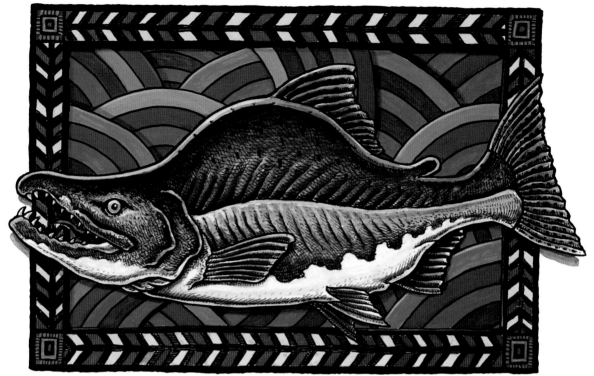

DON'T WORRY, BE HUMPY

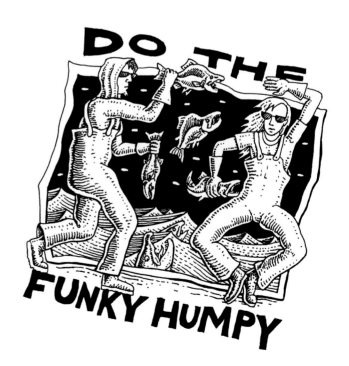

DO THE FUNKY HUMPY

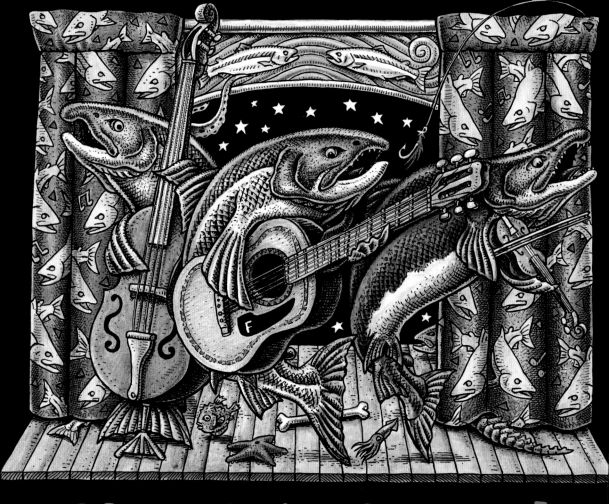

JAMMIN' SALMON!

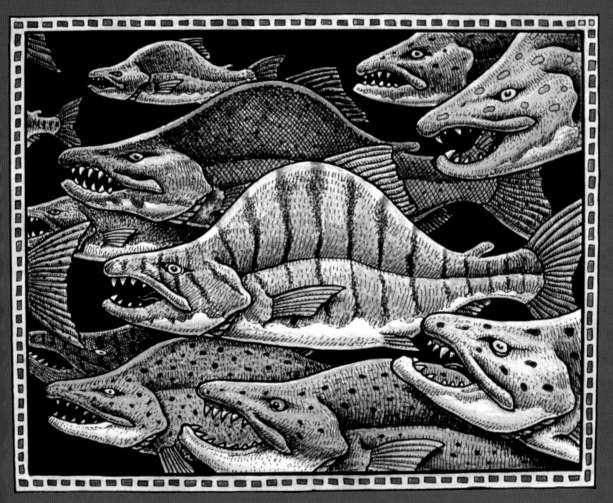

HUMPIES FROM HELL

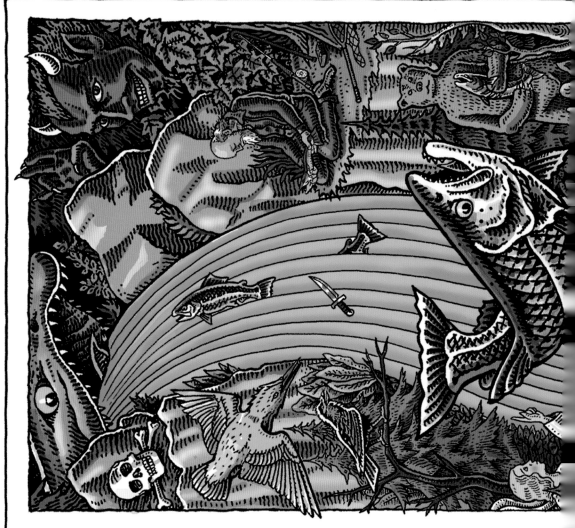

LIFE IS BUT A STREAM

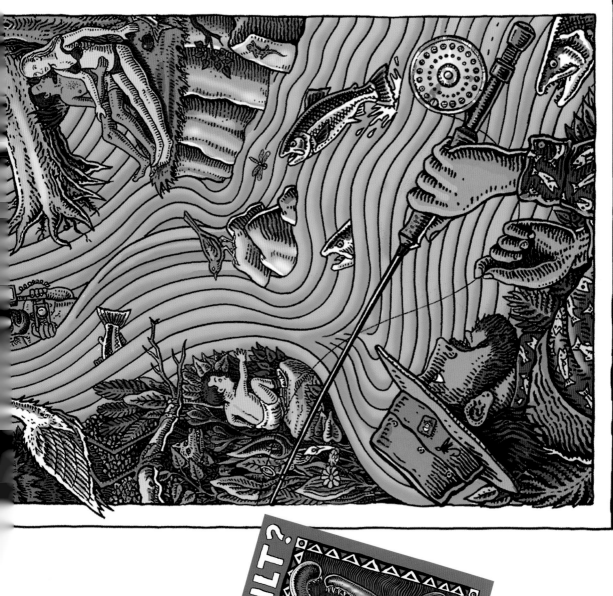
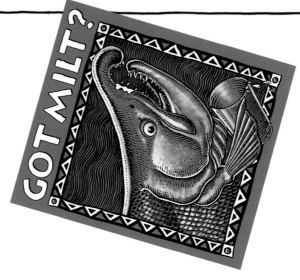

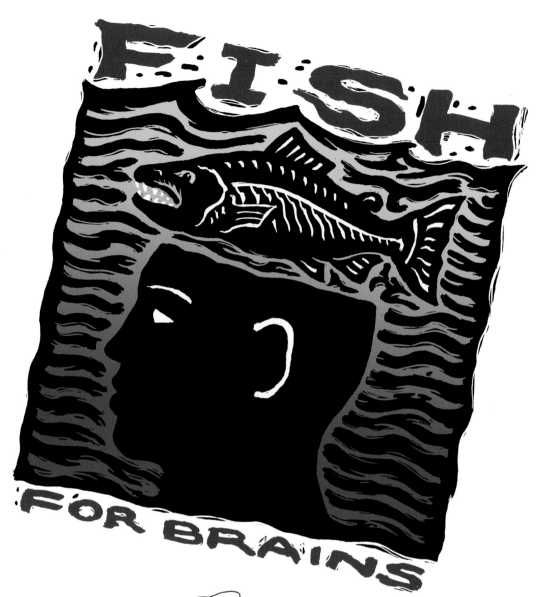

FISH

FOR BRAINS

THE BOTTOM LINE

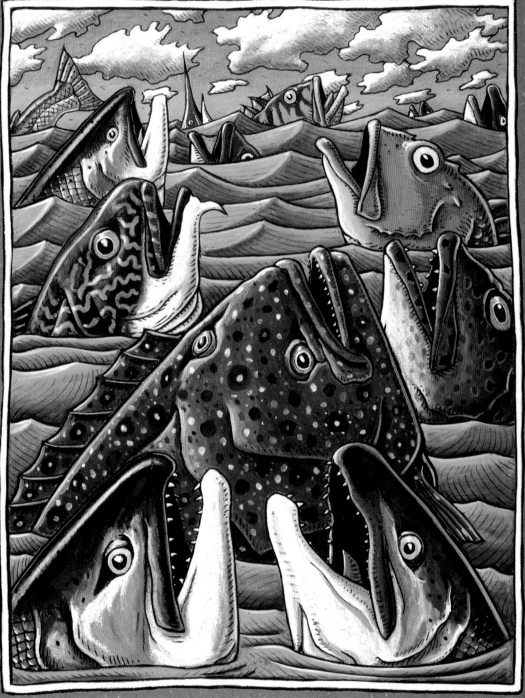

THE FISH ARE CALLING

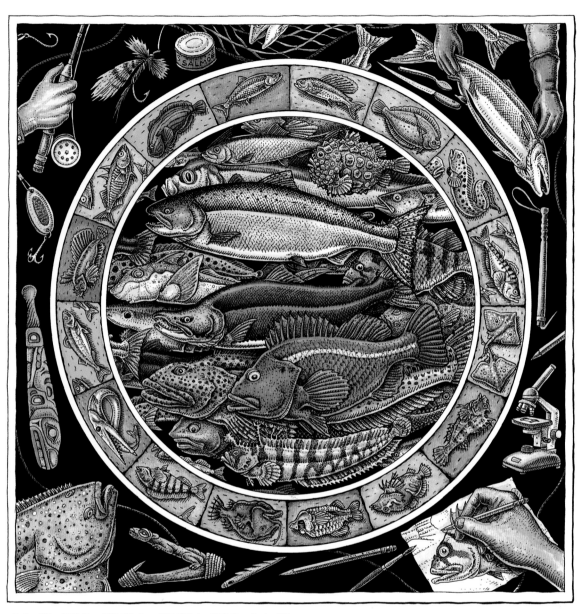

LIVE TO FISH, FISH TO LIVE

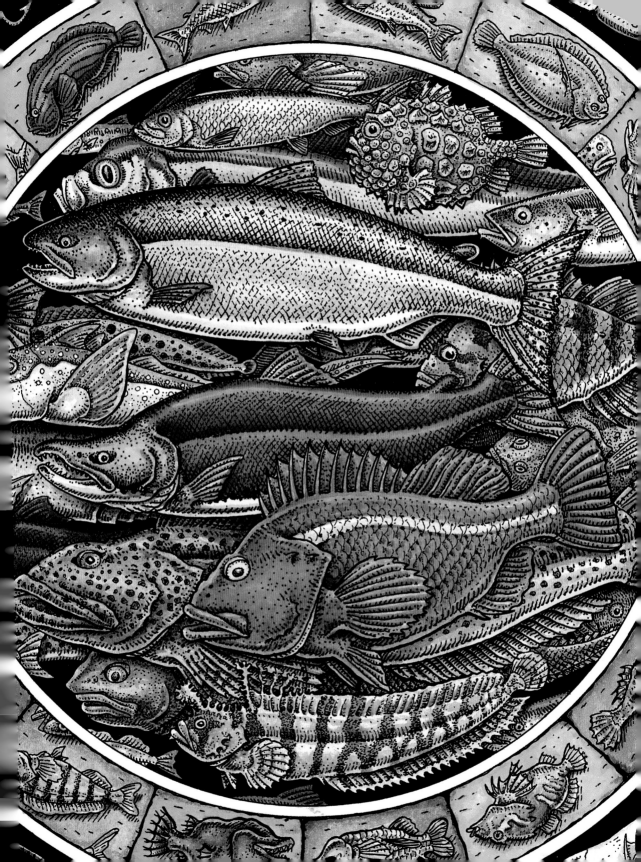

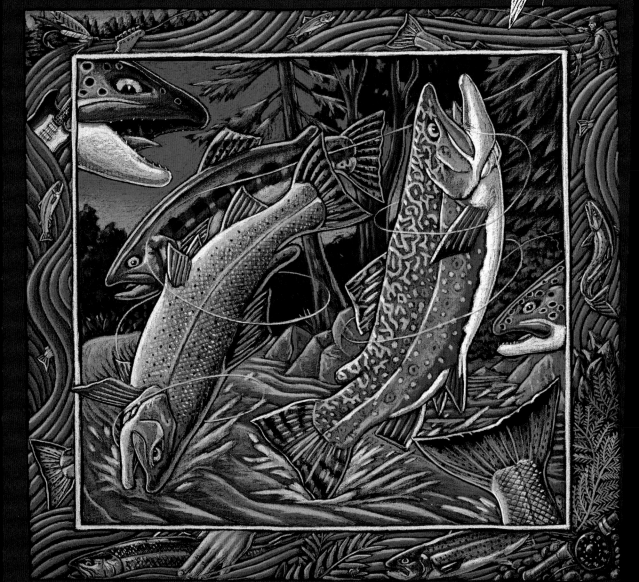

TWIST AND TROUT!

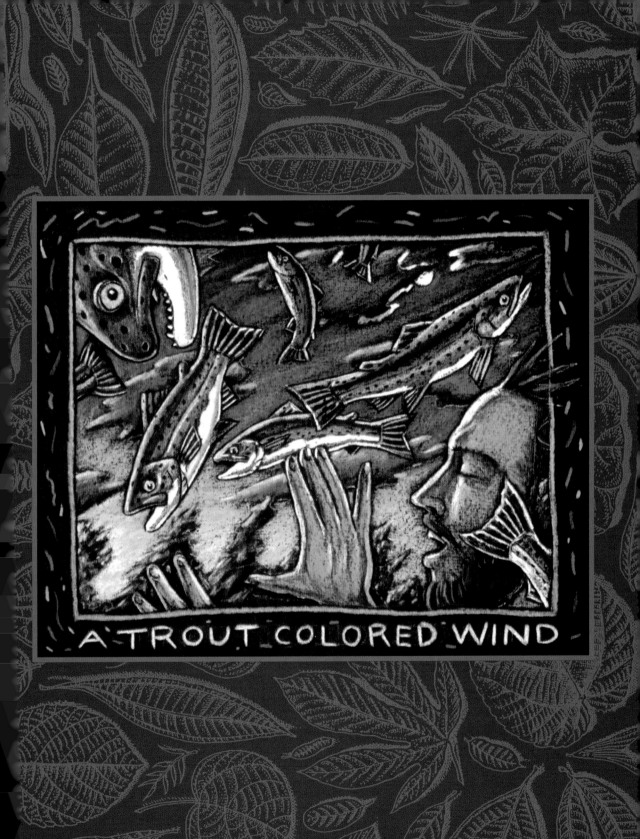

A TROUT COLORED WIND

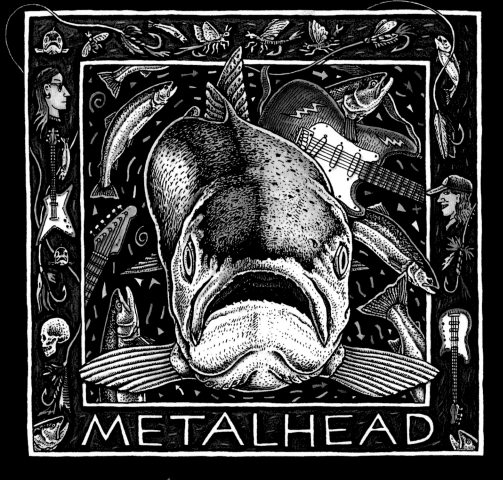

METALHEAD

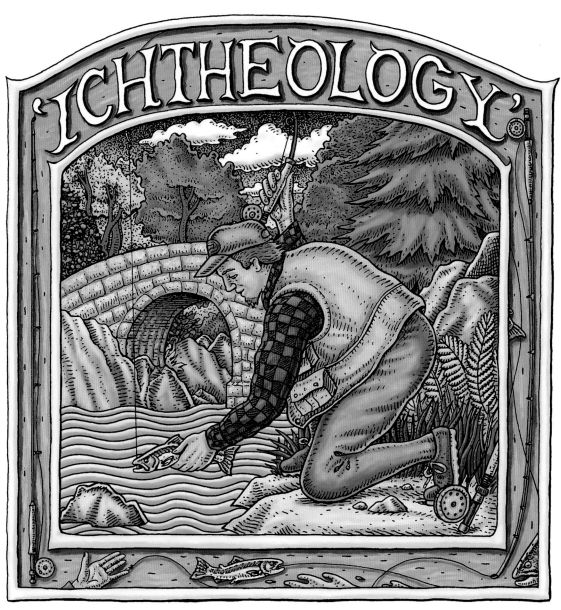

THY ROD AND THY REEL COMFORT ME

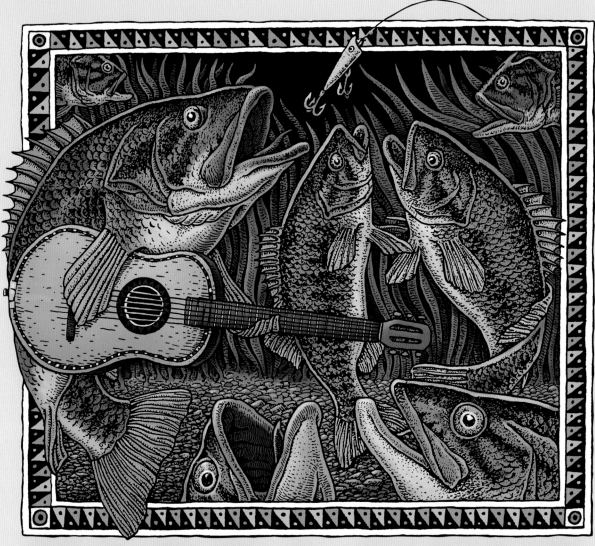

BASSA NOVA

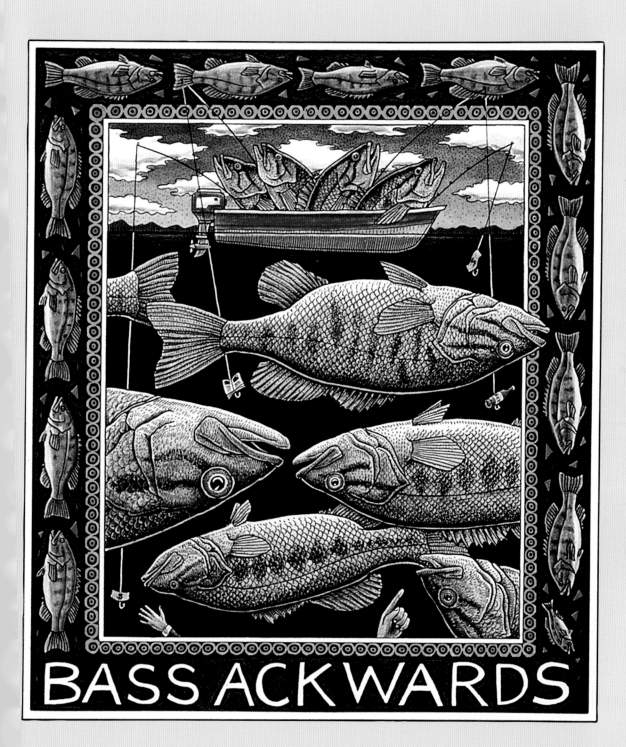

BASS ACKWARDS

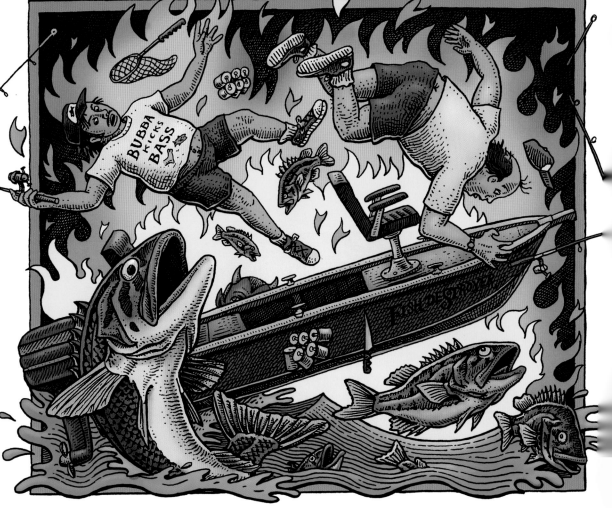

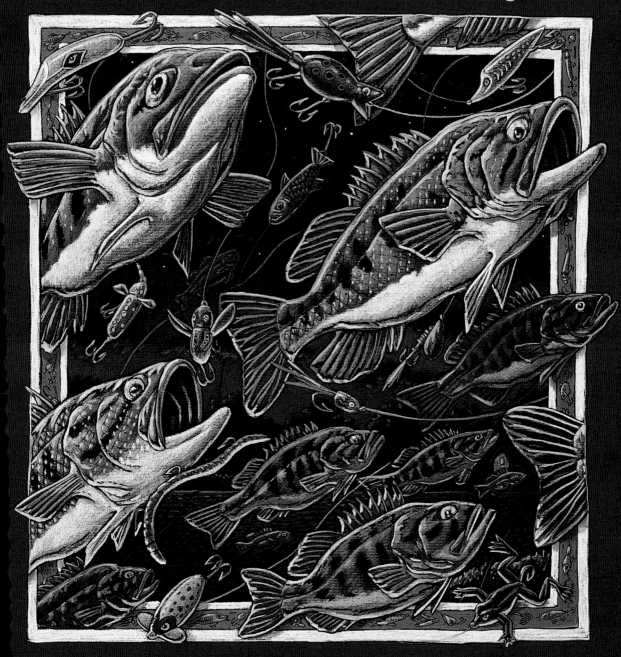

WEAPONS OF BASS DESTRUCTION

COMBAT FISHING

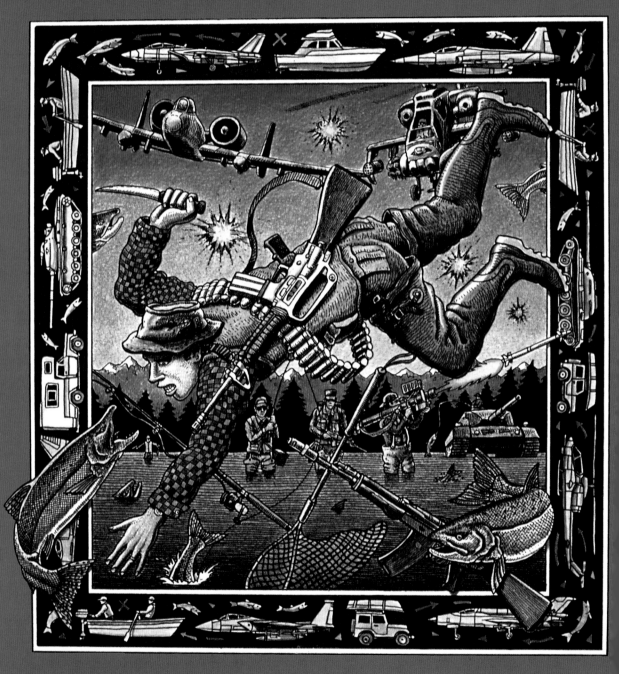

SOCKEYE KILLER

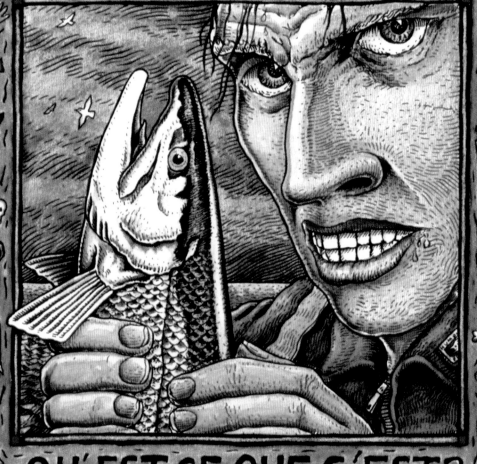

QU'EST-CE QUE C'EST?

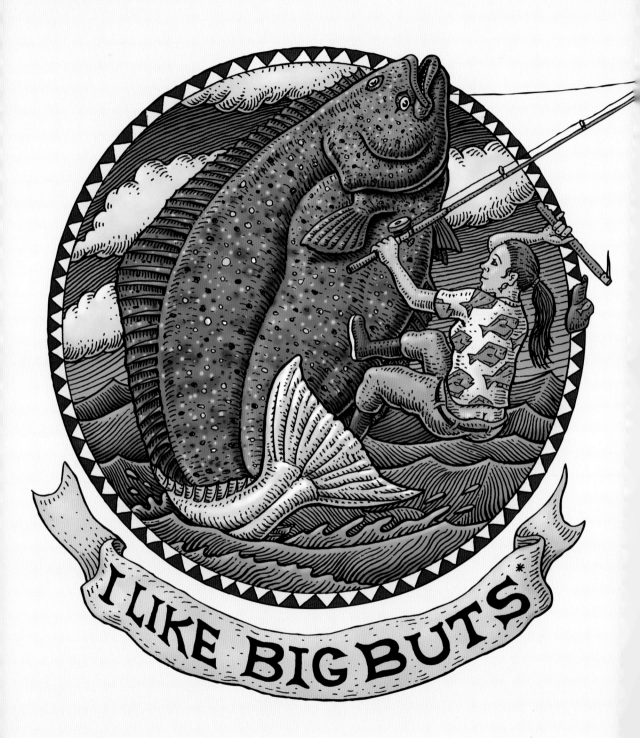

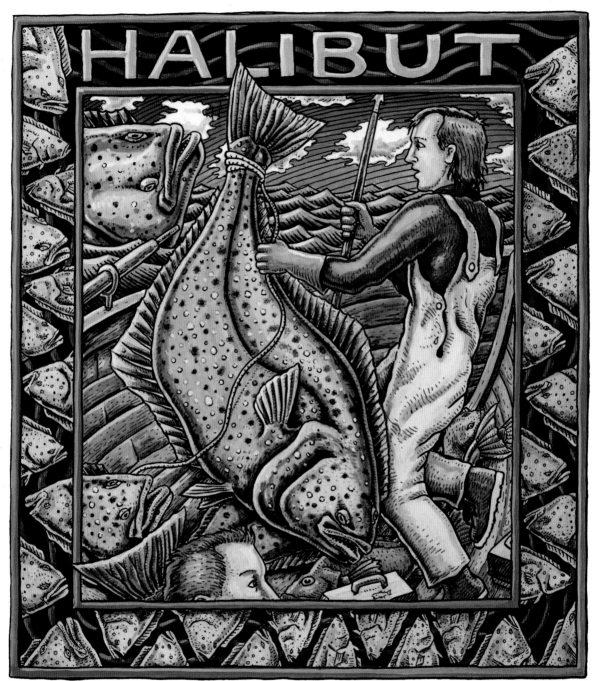

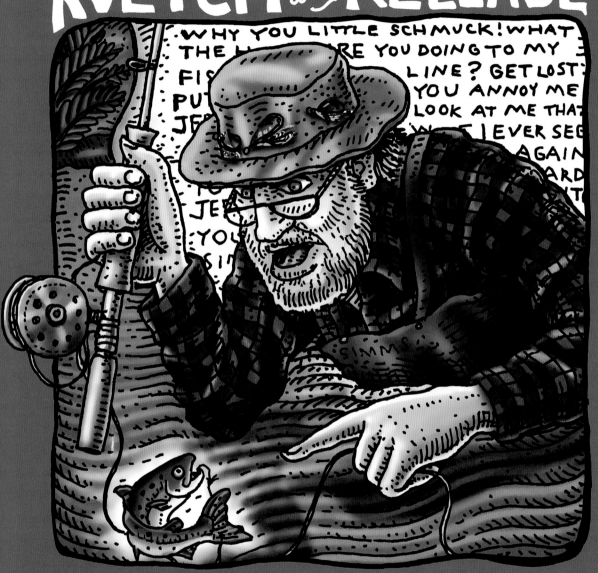

IN SEARCH OF THE
HOLY GRAYLING

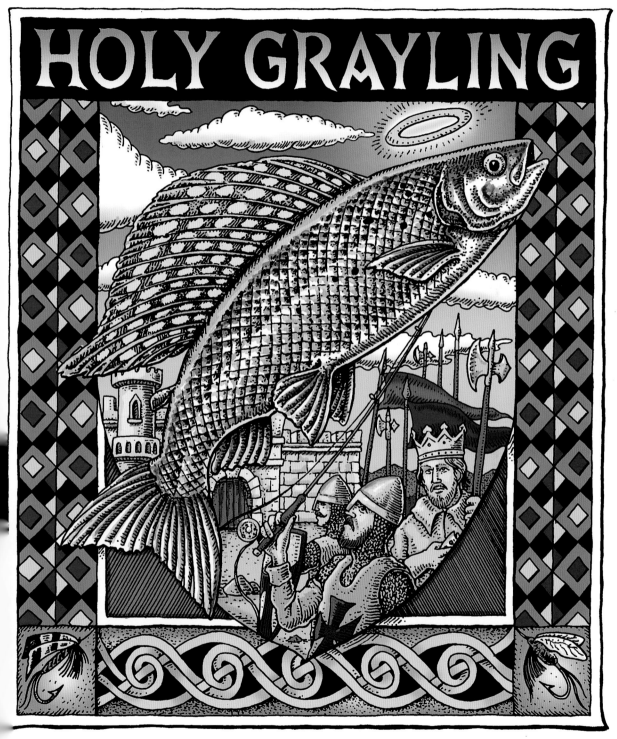

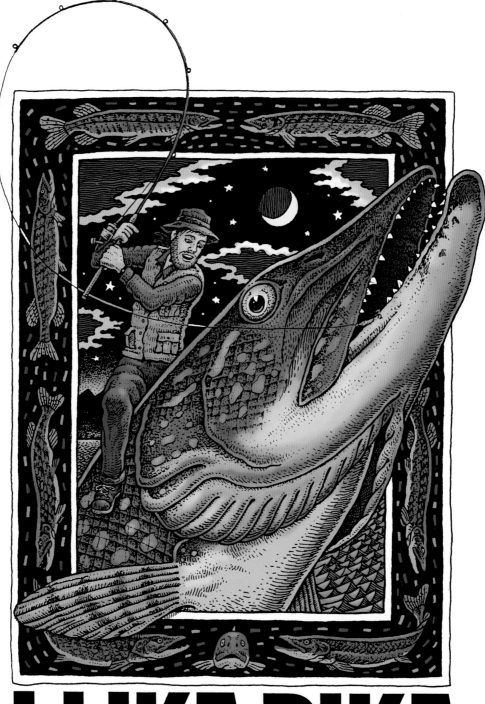

I LIKE PIKE

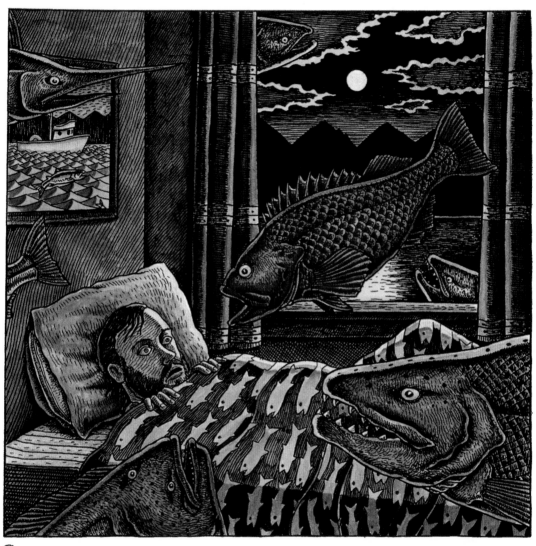

SOMETIMES LATE AT NIGHT THE SPIRITS OF ALL THE FISH
I'VE EVER CAUGHT COME BACK TO HAUNT ME.

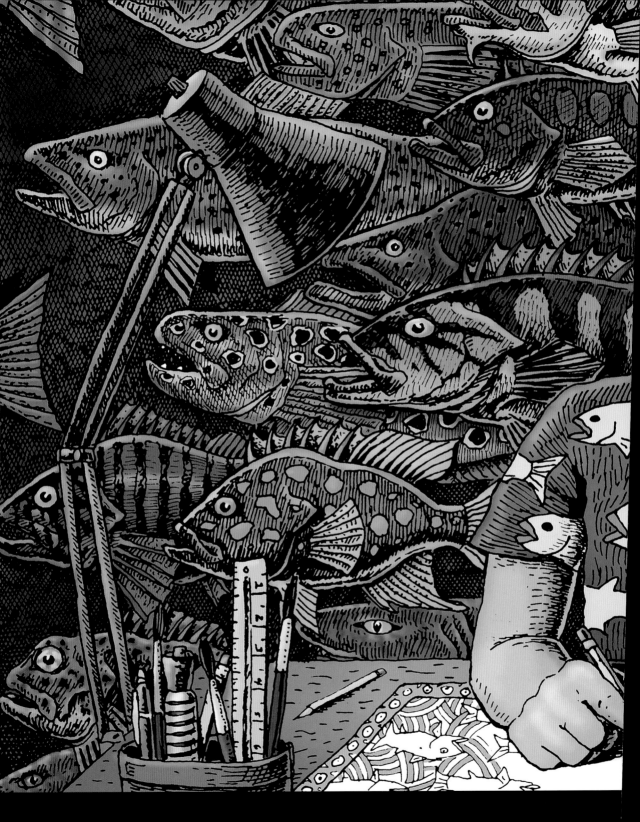

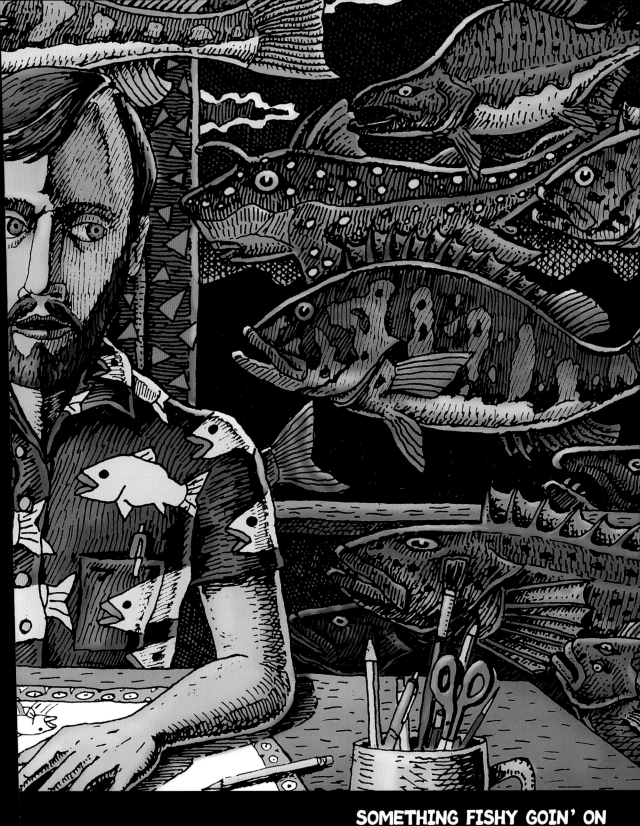

SOMETHING FISHY GOIN' ON

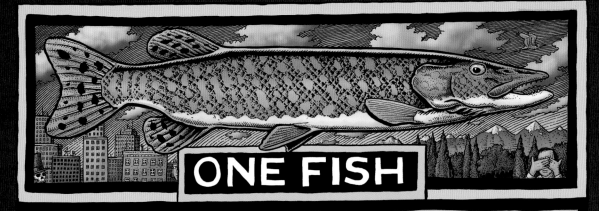

ONE FISH

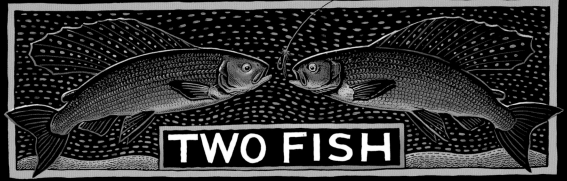

TWO FISH

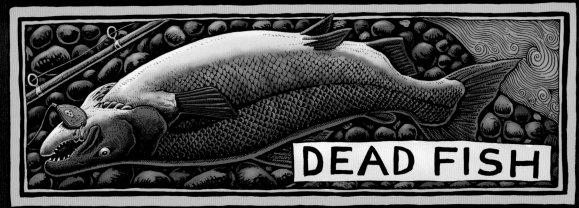

DEAD FISH

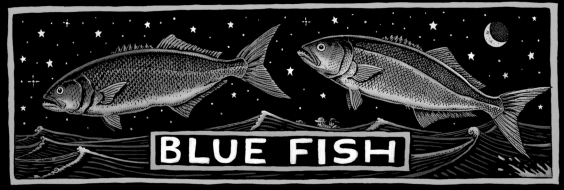

BLUE FISH

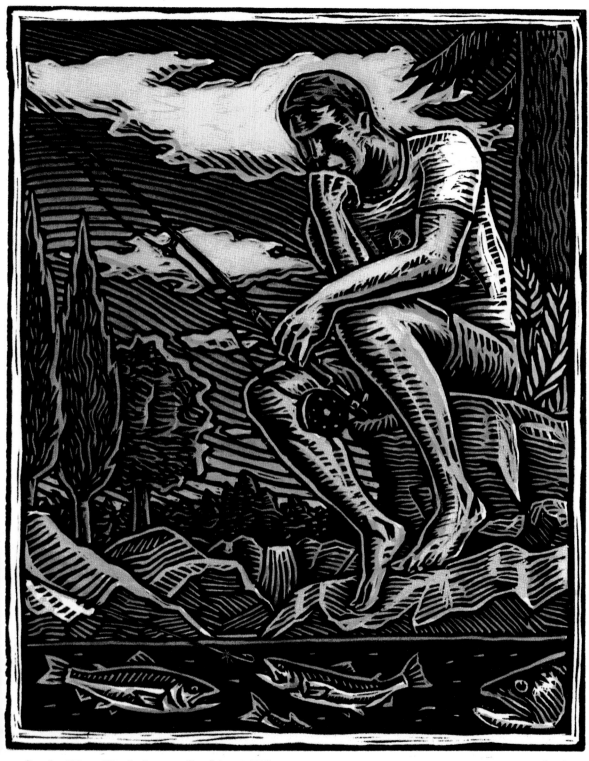

HOOK, LINE AND THINKER

IF YOU MUST SMOKE

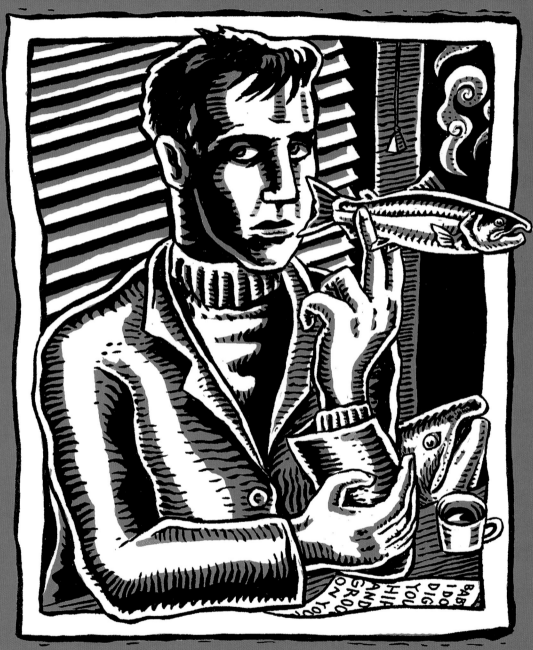

SMOKE SALMON

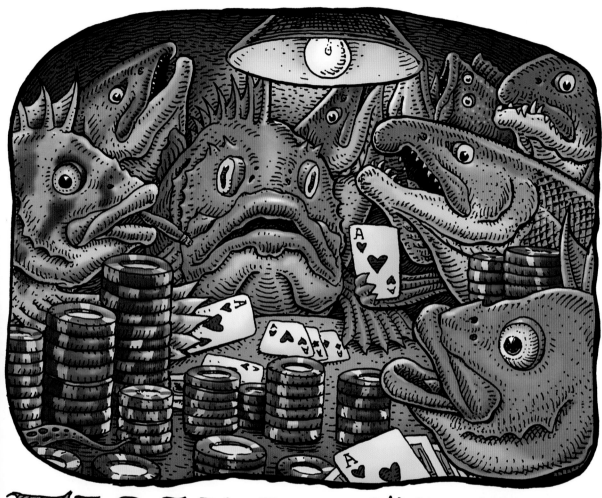

FISH AND CHIPS

THE DaVinci COD

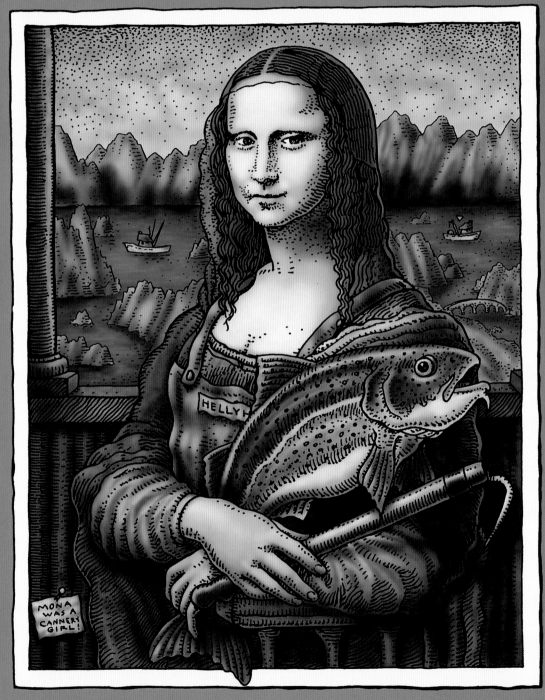

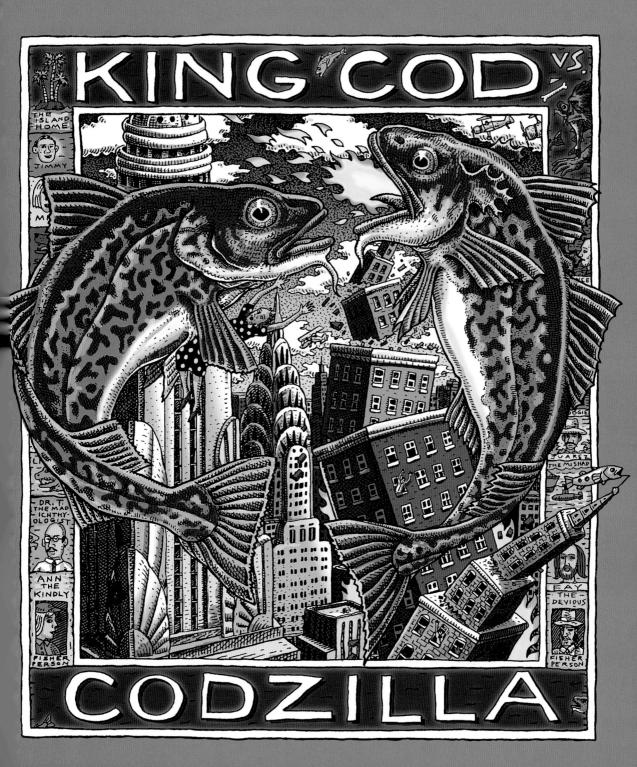

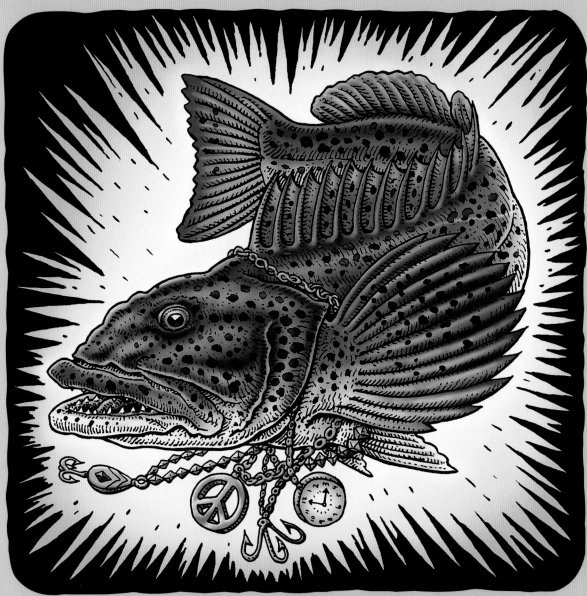

BLING COD

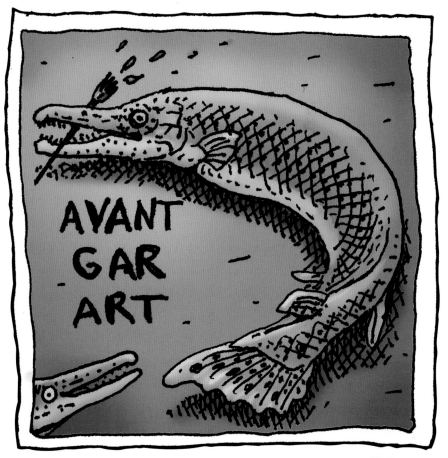

AVANT
GAR
ART

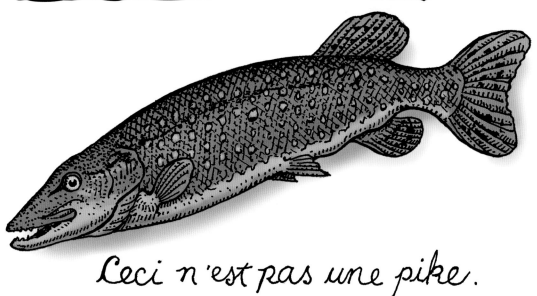

Ceci n'est pas une pike.

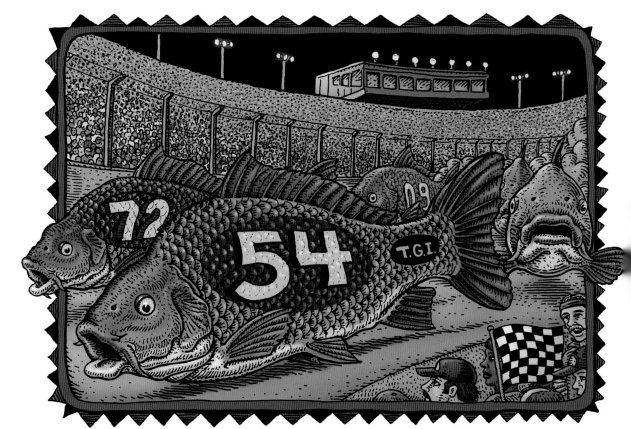

NASCARP!

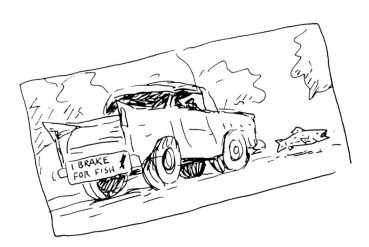

I BRAKE FOR FISH

WALLEYE STREET JOURNAL.

"PISCEAN POWER" "LING COD WE TRUST" — 50 CLAMS

►ENTERTAINMENT

► WALLEYE AND THE BEAV

SPLITSVILLE FOR THE CLEAVERS?

IN HAPPIER DAYS

►WARD AND JUNE, PARENTS OF WALLEYE AND THE BEAV HAVE ISSUED A JOINT PRESS RELEASE PROCLAIMING AN IMPASSE IN NEGOTIATIONS BETWEEN WALLEYE AND THE BEAV AFTER DAYS OF BITTER DISPUTE BETWEEN THE TWO CHILD-STARS. WALLEYE HAS SAID "I'M TIRED OF BEAV'S

SEE PAGE TWO

►WALLEYE CRONKITE USED AS CO-ANCHOR

NO CLUES FOUND

►IN A BIZARRE SERIES OF EVENTS WALLEYE CRONKITE AND HIS COUNTERPART DAN RATHER-B.-FISHING WERE FOUND BOUND TOGETHER WITH CHAINS. THEY WERE APPARENTLY BEING USED AS CO-ANCHORS IN A LITERAL SENSE. AFTER FINISHING AN IN-DEPTH (NO PUN INTENDED) INTERVIEW WITH PIKE EISENHOWER TWO SUSPECTS APPROACHED SAYING 'WHAT'S THE FREQUENCY KENNETH?" SEE PG.7

►TRAVEL SECTION INSIDE

►PIKE'S PEAK: MOUNTAIN OR FISH?

►THE GREAT WALLEYE OF CHINA

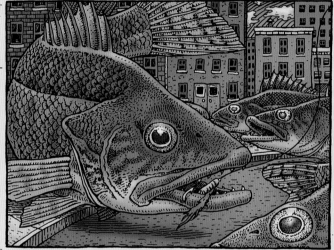

MAKING A KILLING ON WALLEYE STREET

BYSTANDERS SHOCKED AS THEIR FOOLISH FRIEND BITES THE BAIT

"HE'S A KEEPER" CRIES KILLER

CROWD LOOKS ON IN HORROR AS VICTIM IMPALED ON HOOK

BY I.B. PERCH

IN WHAT IS BECOMING AN EVERYDAY OCCURENCE ANOTHER FINNY CITIZEN HAS BEEN TAKEN FROM OUR MIDST. IN BROAD DAYLIGHT, WALTER J. WALLEYE FROM WALLA WALLA WASHINGTON ON WHAT WAS HIS FIRST VISIT TO THE WILD AND WOOLY BIG CITY WAS HEARTLESSLY YANKED BY A SHARP HOOK UPWARDS AND OUT OF SIGHT.

►"THIS KIND OF THING SEEMS TO BE HAPPENING ALL THE TIME THESE DAYS" SAID POLICE CHIEF CAPTAIN PERCHY O' DERBY. "THESE POOR OUT OF TOWN SUCKERS SHOW UP AND BAM THEY'VE FALLEN FOR ONE OF THESE ARTI-FISH-AL LURES OR WIGGLY WORMS. THEY'RE JUST PLAIN NOT AWARE OF THE DANGER. ANY FOOL CAN SPOT THE HOOKS PROTRUDING FROM THESE DEVICES OF CRUEL DECEPTION."

► THE LATEST VICTIM WAS MAKING HIS WAY UPTOWN TO CATCH THE LATEST WALLEYE

BRONSON FLICK "DEATH FISH III" WHEN HE FELT AN URGE TO HAVE A SNACK. STOPPING AT WHAT APPEARED TO BE SIDEWALK CAFE ON WALLEYE STREET HE SOON SPOTTED A TASTY MORSEL DANGLING ABOVE HIS HEAD. QUICKER THAN YOU CAN SAY 'WALLA WALLA WALLEYE THE DEADLY HOOK FOUND ITS MARK.

► THE VICTIM STRUGGLED HEROICALLY FOR NEARLY FIVE MINUTES BEFORE BEING PULLED UPWARDS. "NO! NO! NO!" HE CRIED

SEE PAGE 13

E-FISH-ENCY APARTMENT BURNS!

BY HAL E. BUTTZ

► FISH CITY O-FISH-ALS WERE AT A LOSS TODAY FOR AN EXPLANATION OF THE TERRIBLE FIRE THAT STRUCK AN APARTMENT COMPLEX YESTERDAY. HOW DID IT START? NO ONE SEEMS TO KNOW.

► AT LEAST TEN RESIDENTS PERISHED IN THE BLAZE. "SOME LOOKED DEEP FRIED, OTHERS WERE LIGHTLY BROILED WITH A DASH OF BUTTER AND GARLIC. "KIND OF YUMMIE IF

SEE PAGE A-10

FISHY INFERNO

WALLEYE HICKEL ELECTED IN ALASKA

► AN ANCIENT FISH FROM THE NIXON ERA HAS RETURNED FROM OUT OF THE DEEP BLUE IN AN..

SEE PG. 2

HICKEL

SEE THE O-FISHAL STORY ON BASSBALL - SPORTS SECTION

A-1

THE ARCHFISHOP

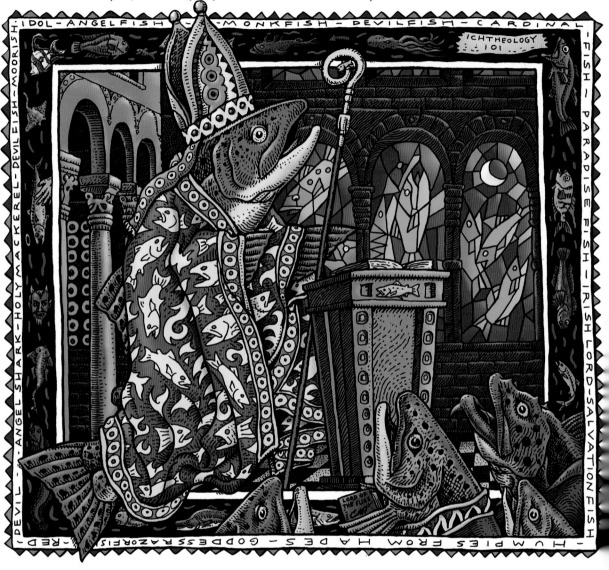

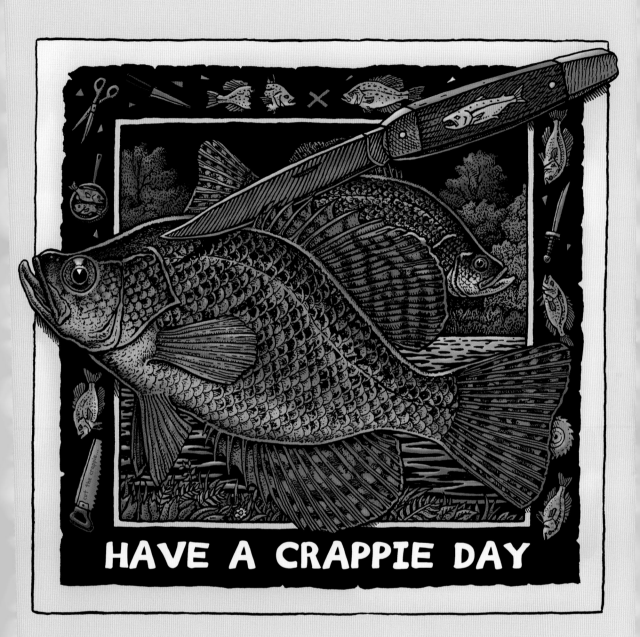

HAVE A CRAPPIE DAY

COD IN THE ACT

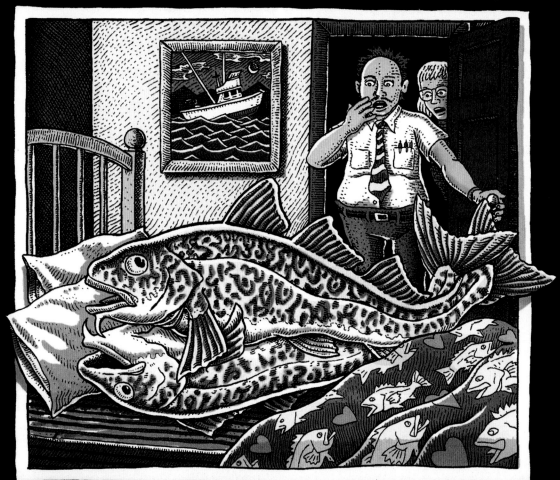

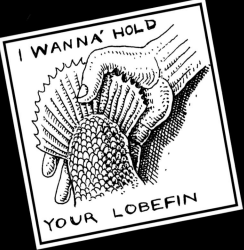

I WANNA' HOLD YOUR LOBEFIN

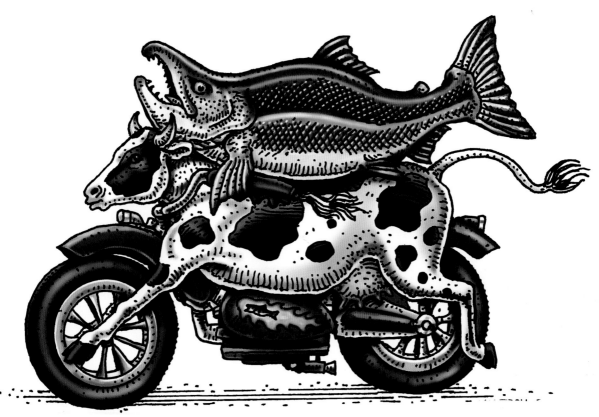

COWASOCKEYE

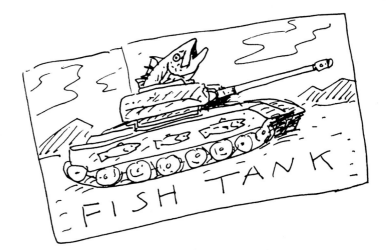

FISH TANK

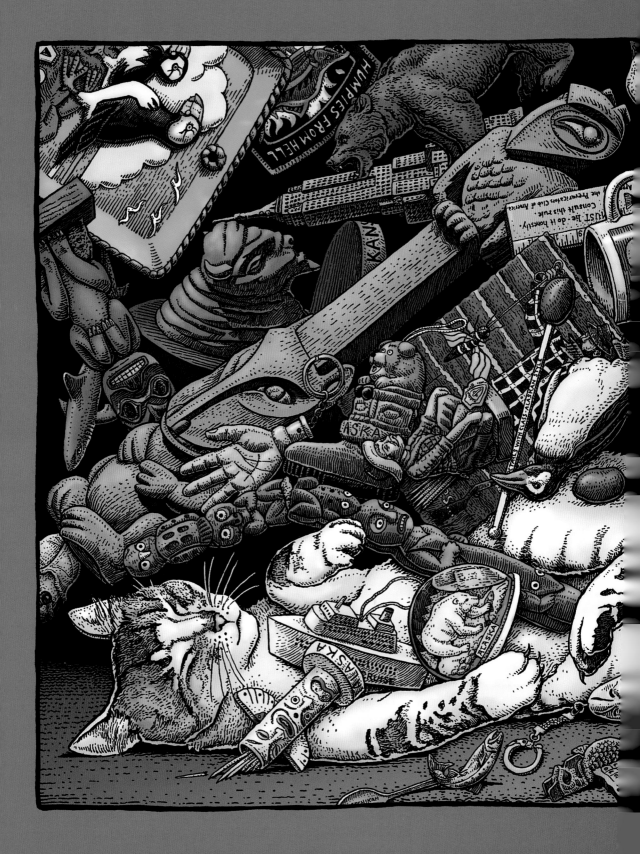

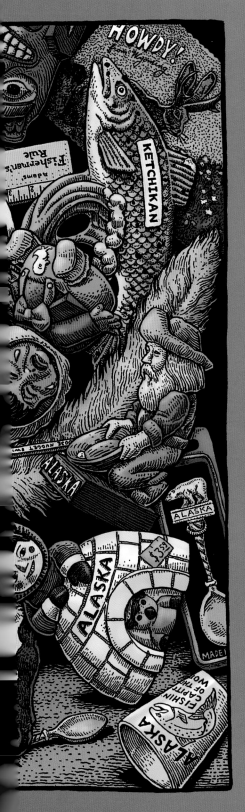

CURIO CITY
KILLED THE
CAT

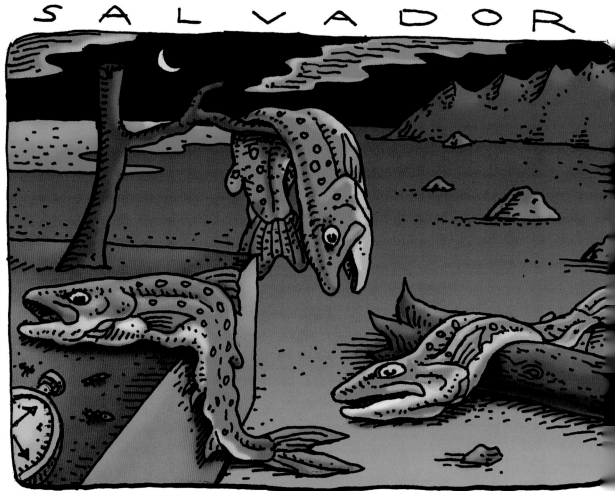

DALÍ VARDEN

OH THE PLACES MY LITTLE PENCIL TAKES ME.

'THE STREAM'

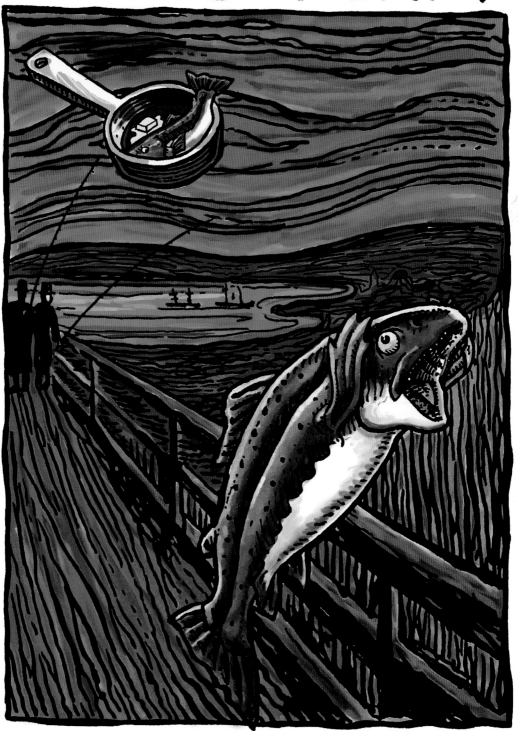

WALK SOFTLY

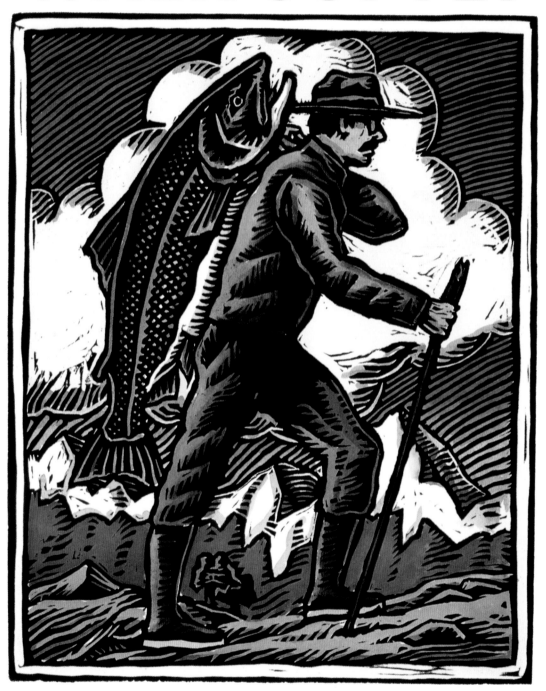

AND CARRY A BIG FISH

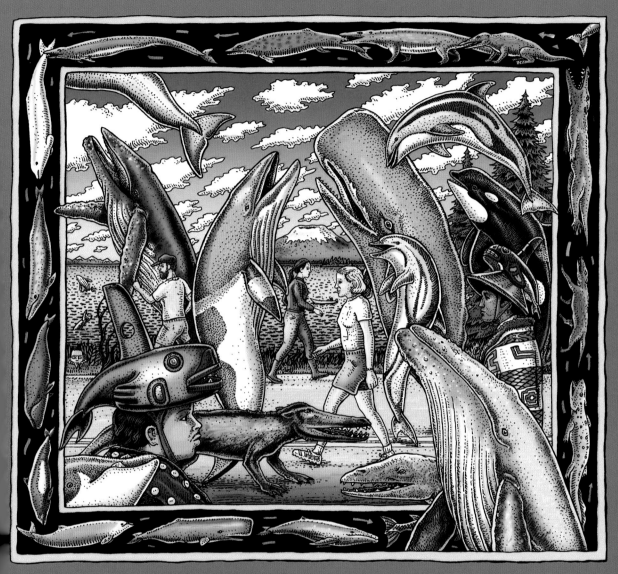

I'VE BEEN WALKING ON THE WHALE ROAD

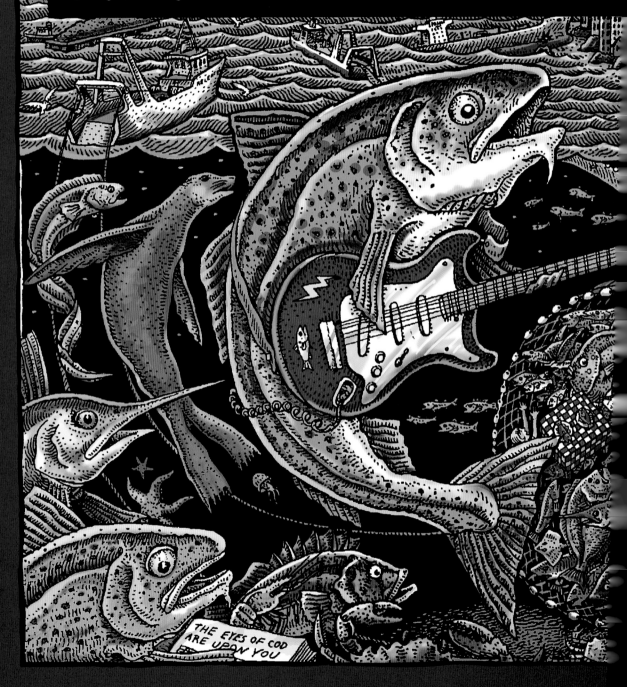

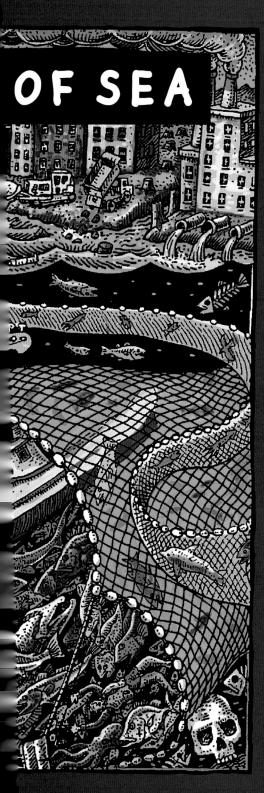

OF SEA

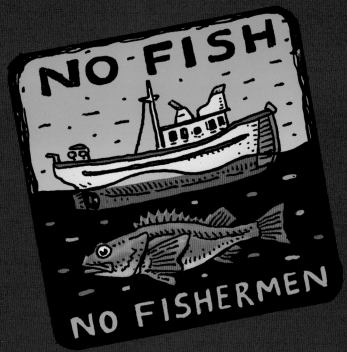

NO FISH

NO FISHERMEN

PULP FISHIN'

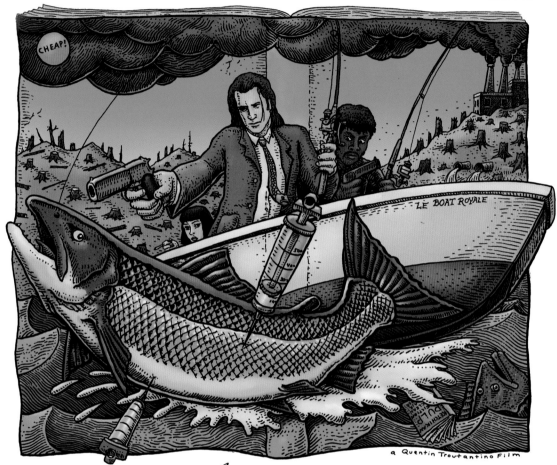

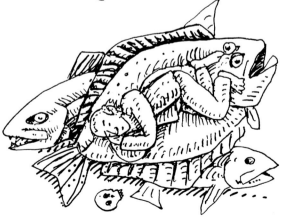

SLEEPING WITH THE FISHES

THE FAMILY THAT PREYS TOGETHER STAYS TOGETHER

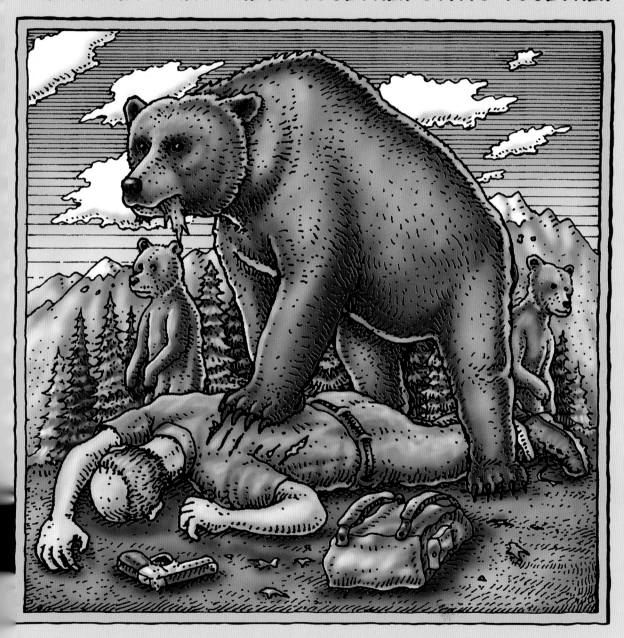

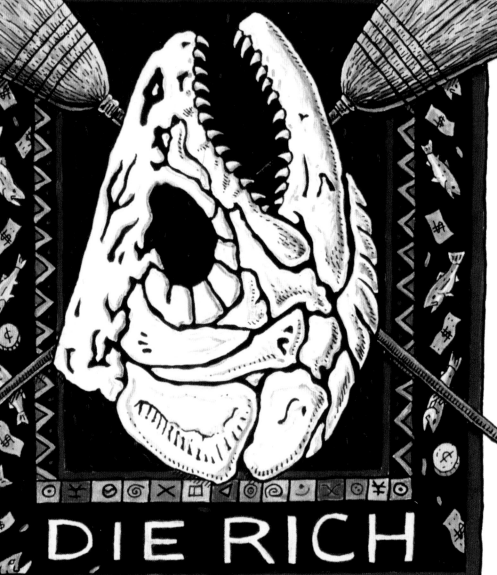

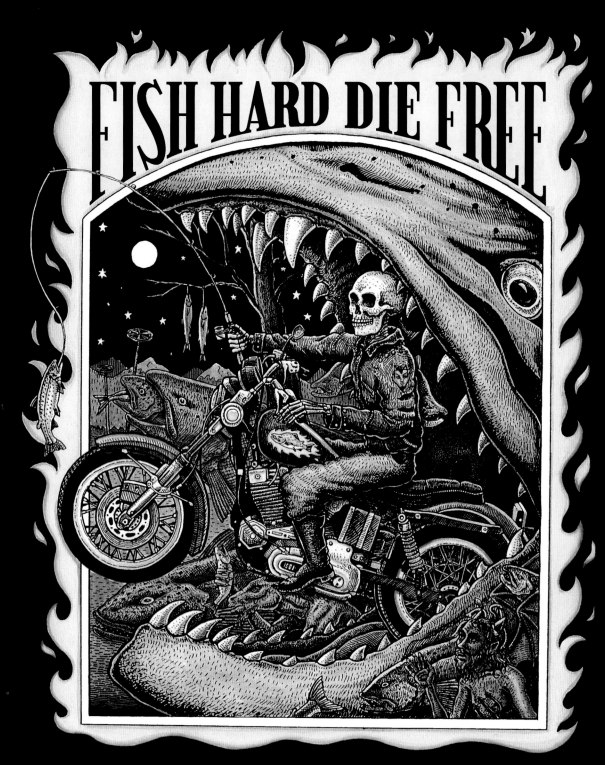

BETWEEN THE DEVIL AND THE DEEP BLUE SEA

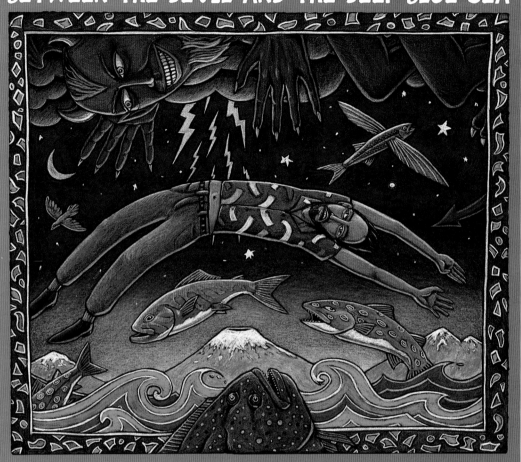

Death Over Easy...

THE DEVIL'S PLAYTHINGS

FISH'WORSHIP

IS IT WRONG?

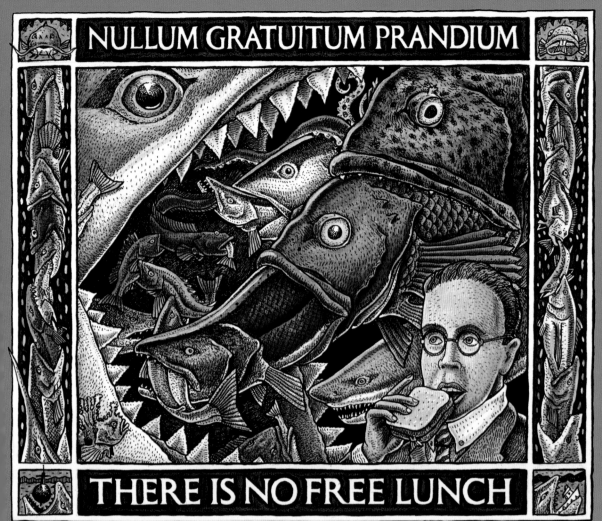

NULLUM GRATUITUM PRANDIUM

THERE IS NO FREE LUNCH

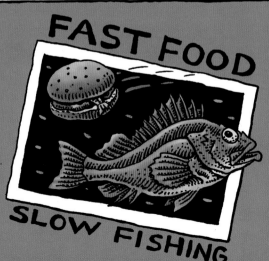

FAST FOOD

SLOW FISHING

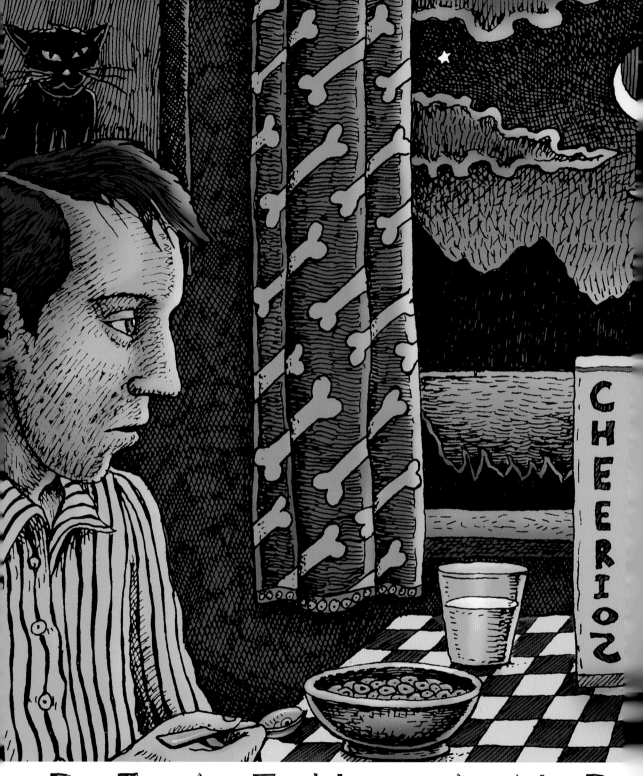

DEATH AND

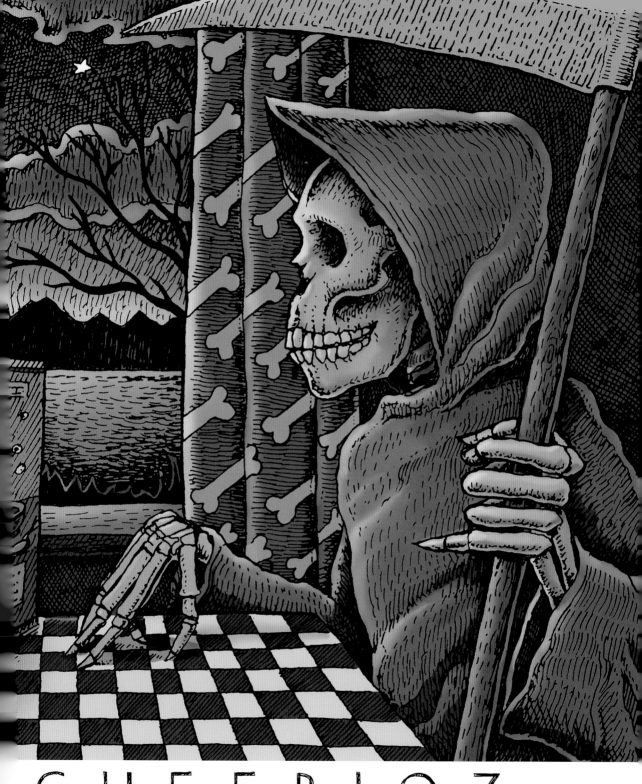

CHEERIOZ

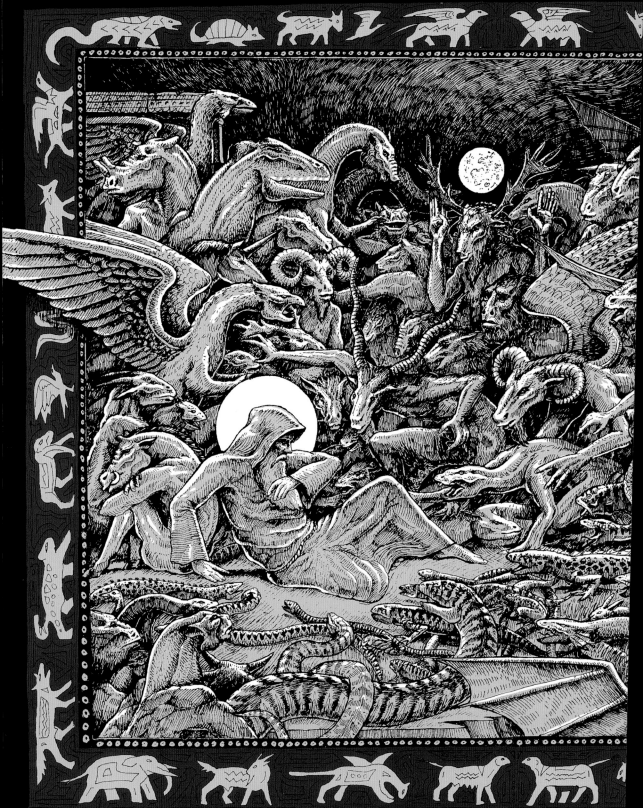

NON ILLEGITIMI
CARBORUNDUM EST:
DON'T LET THE
BASTARDS GRIND
YOU DOWN

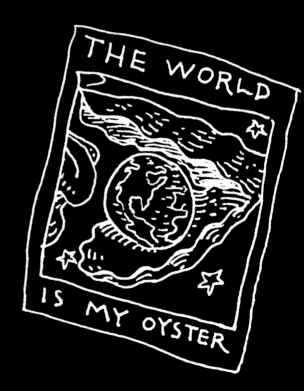

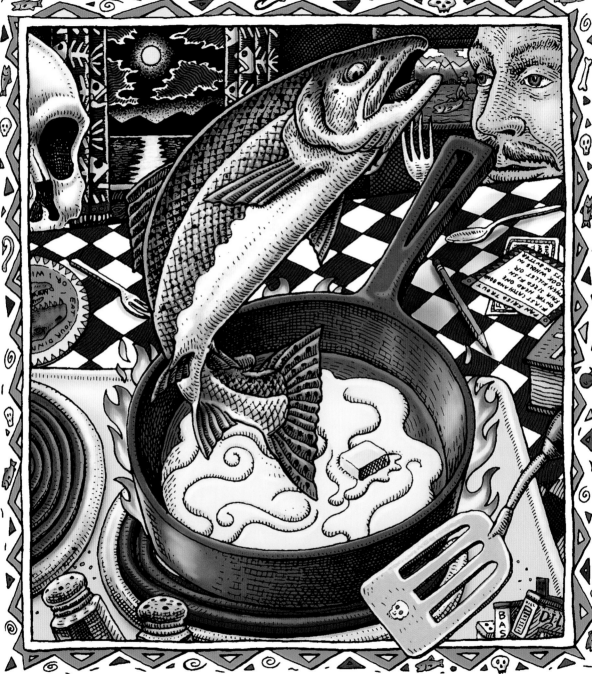

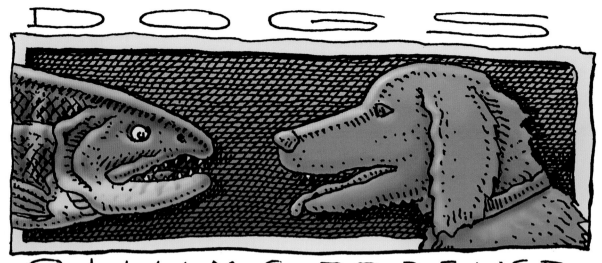

DOGS

CHUMS FOREVER

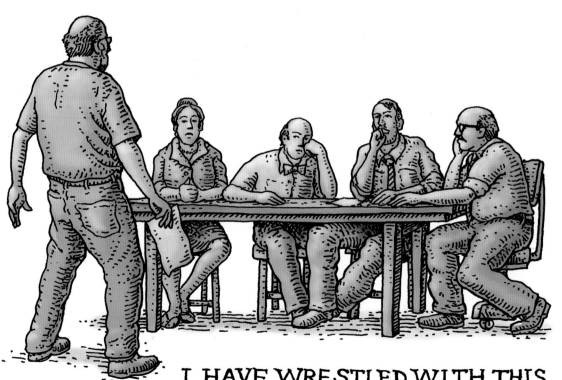

I HAVE WRESTLED WITH THIS
BEAST THEY CALL "COM MIT TEE."

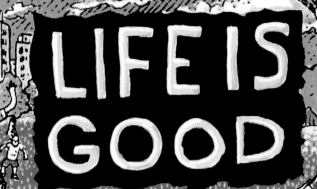

CAREFUL WHAT YOU FISH FOR

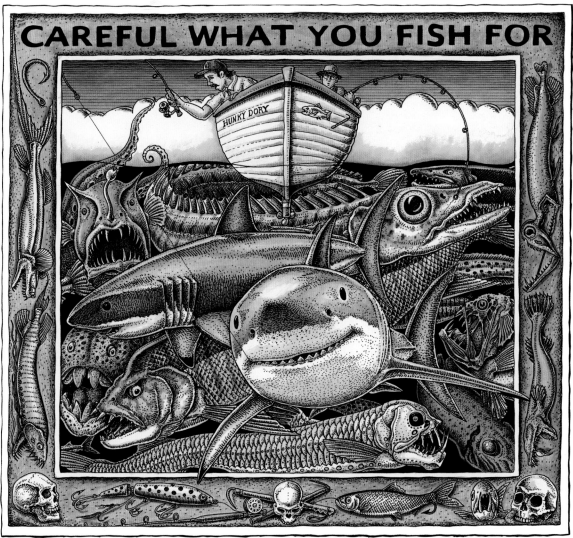

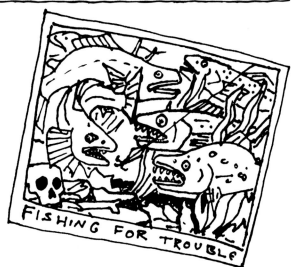

FISHING FOR TROUBLE

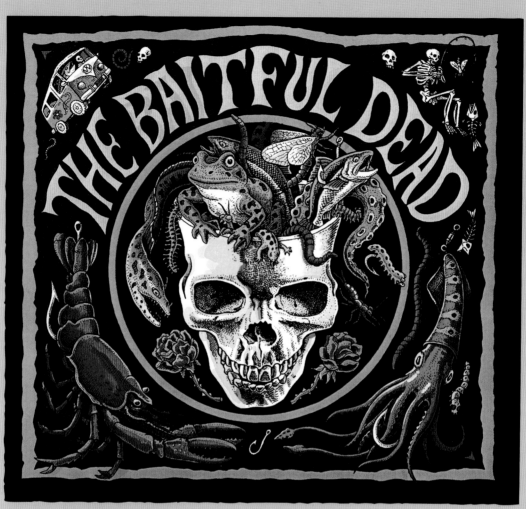

TRUTH IS STRANGER THAN FISHIN'

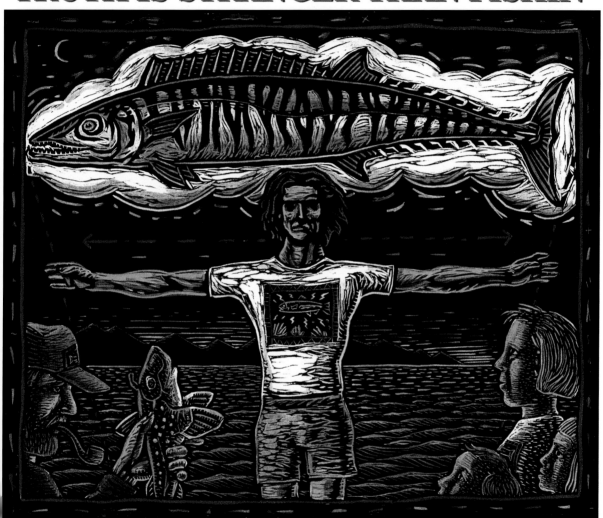

DECAFFEINATED DECAPITATED

KNOW THE DIFFERENCE

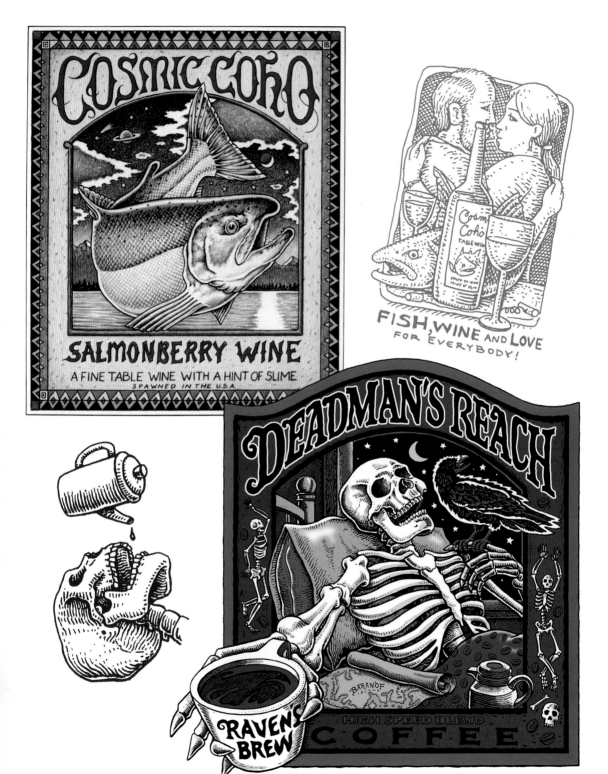

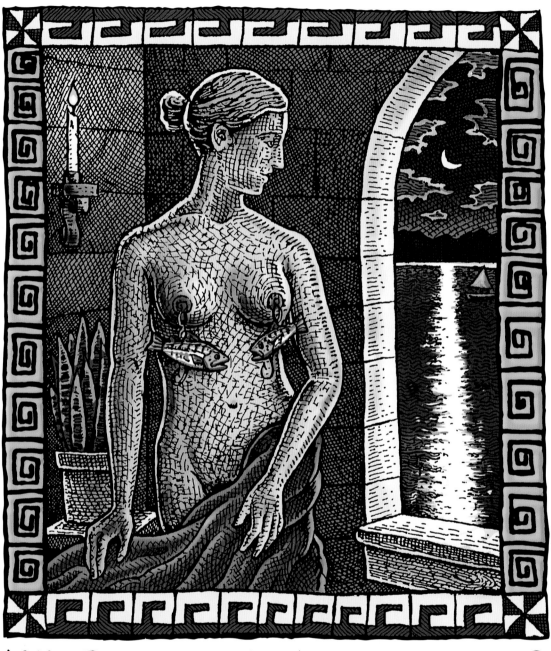

WAITING WITH BAITED BREASTS

THE PERILS OF NUDE FLYFISHING

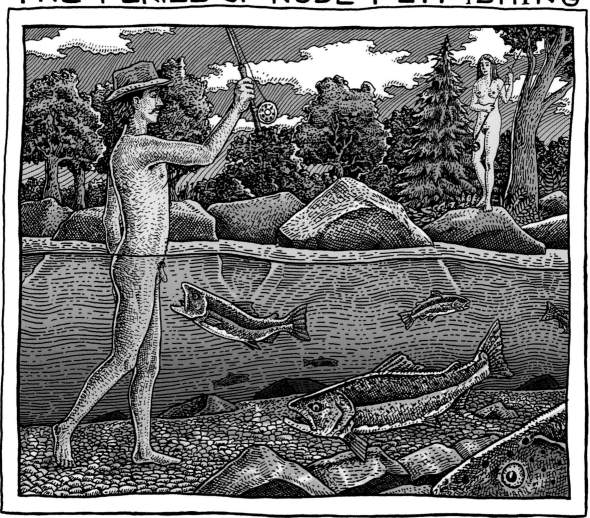

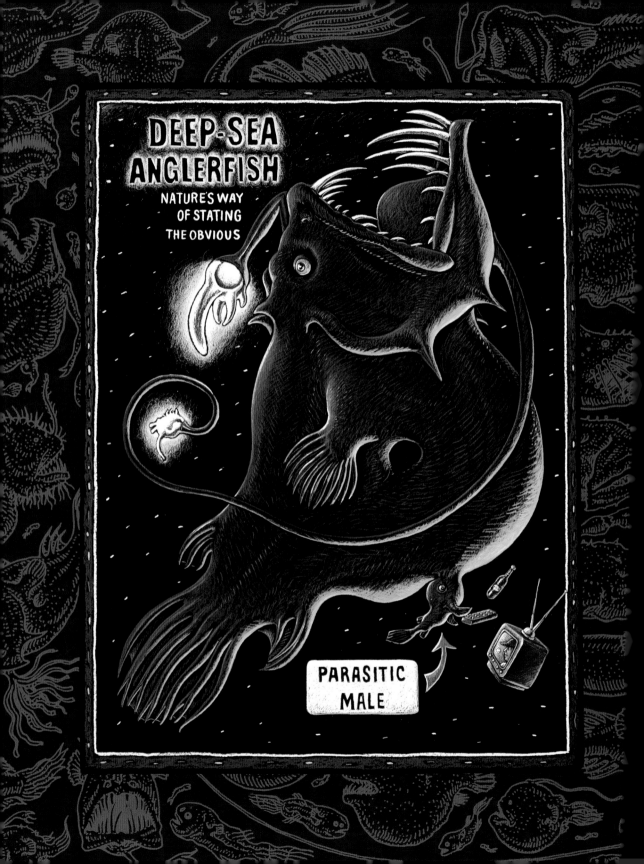

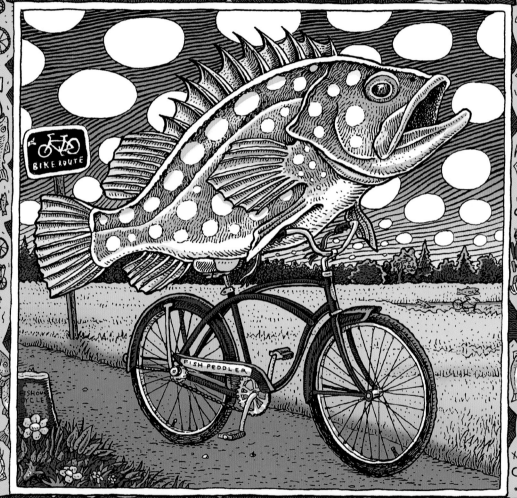

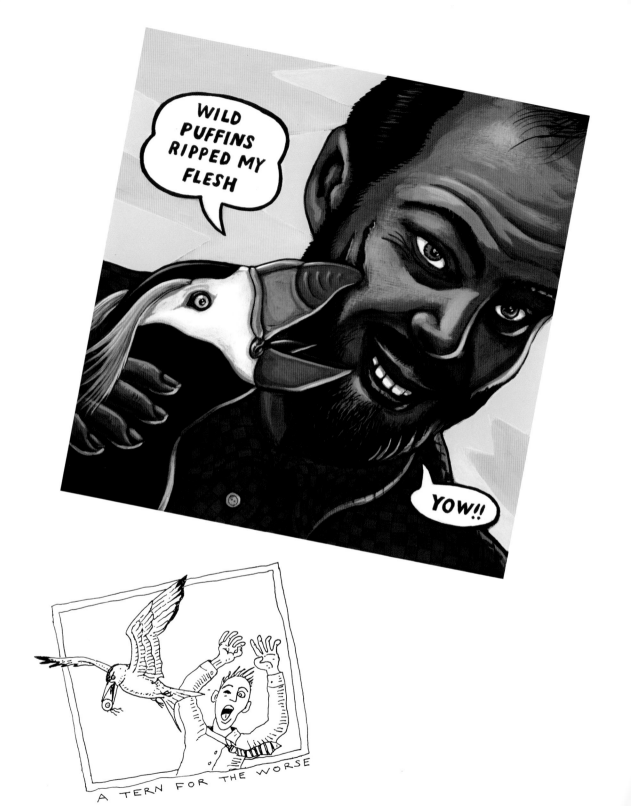

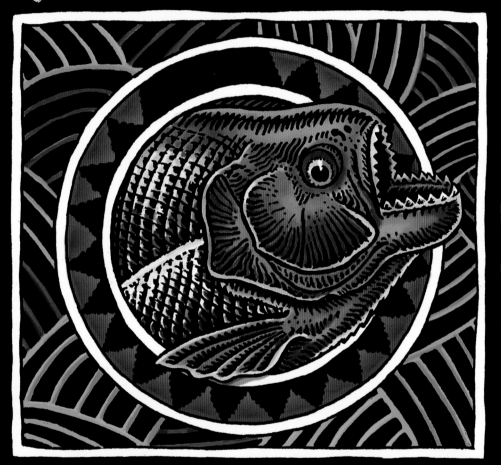
VICIOUS
FISHES!

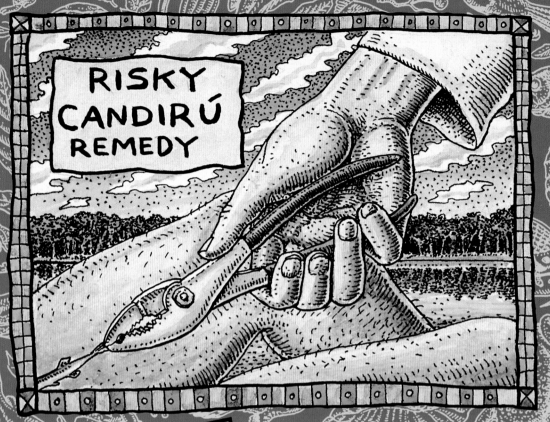

RISKY CANDIRÚ REMEDY

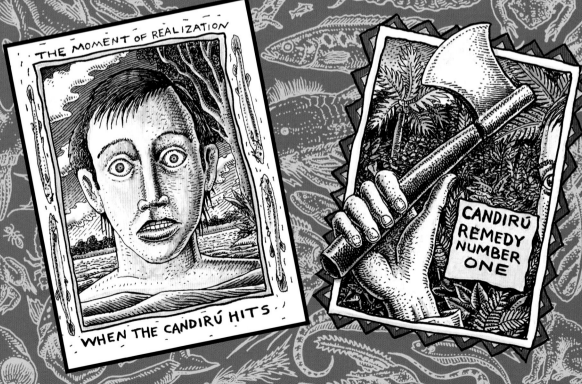

THE MOMENT OF REALIZATION

WHEN THE CANDIRÚ HITS

CANDIRÚ REMEDY NUMBER ONE

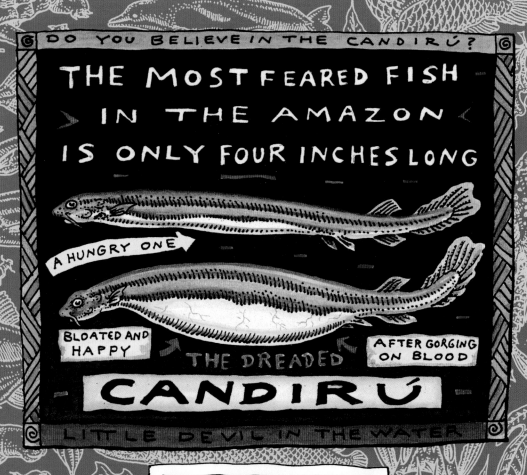

DO YOU BELIEVE IN THE CANDIRÚ?

THE MOST FEARED FISH IN THE AMAZON IS ONLY FOUR INCHES LONG

A HUNGRY ONE

BLOATED AND HAPPY

AFTER GORGING ON BLOOD

THE DREADED **CANDIRÚ**

LITTLE DEVIL IN THE WATER

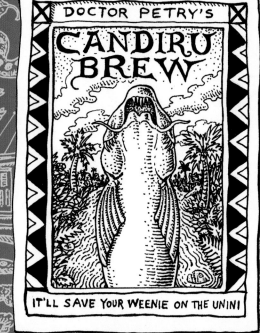

DOCTOR PETRY'S
CANDIRU BREW

IT'LL SAVE YOUR WEENIE ON THE UNINI

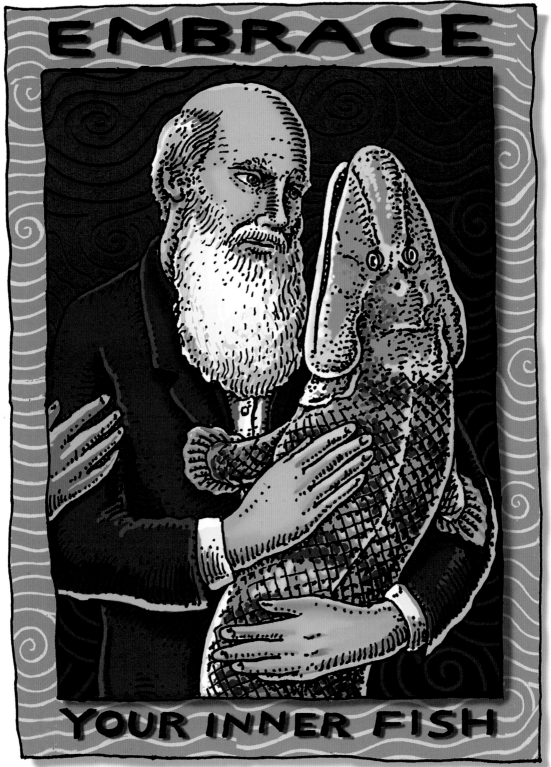

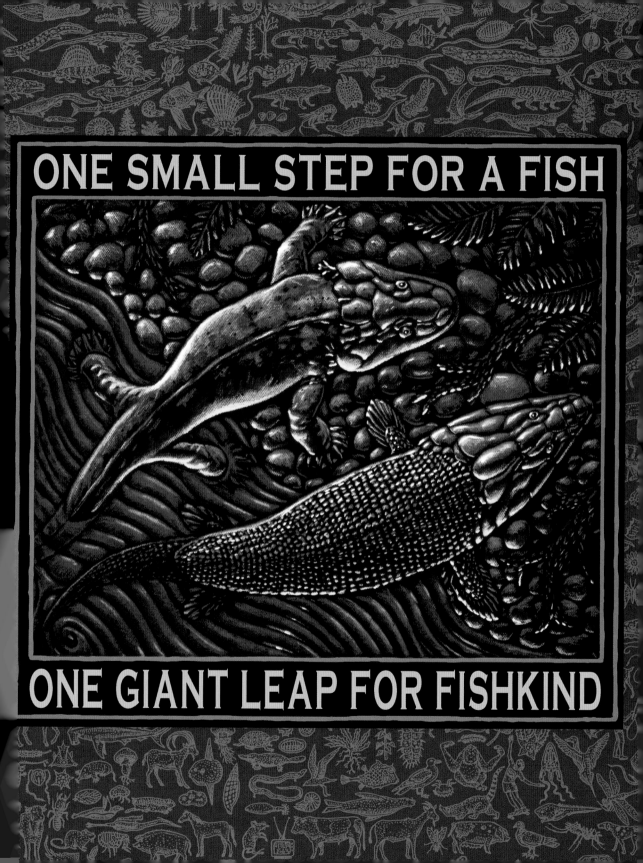

THE WAY WE WERE

A | B | C | D

E | F | G | H

I | J | K | L

M | N | O | P

THE PATH OF HUMAN EVOLUTION

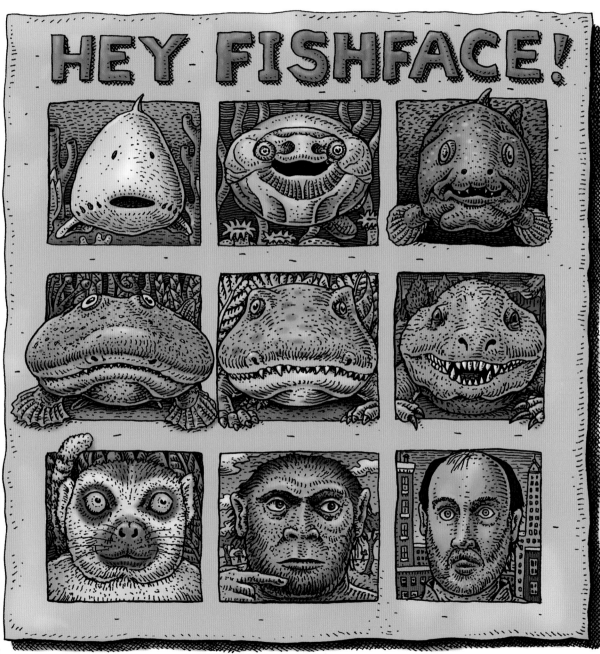

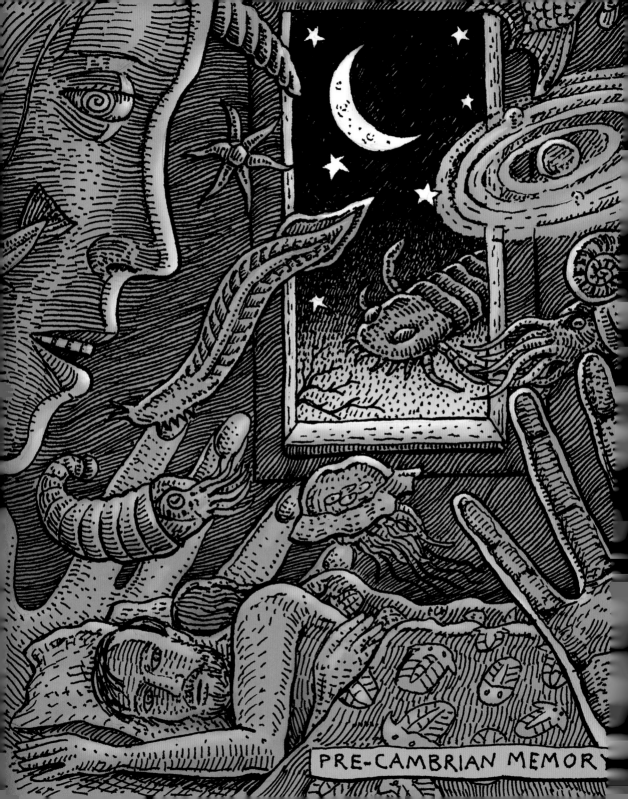

PRE-CAMBRIAN MEMORY

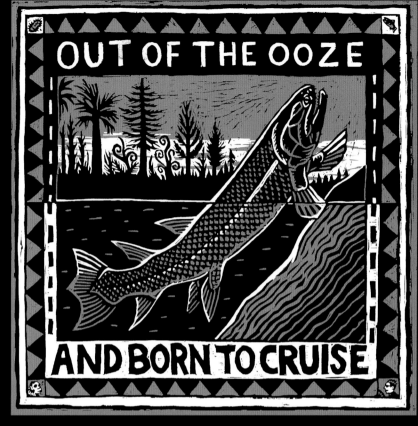

OUT OF THE OOZE

AND BORN TO CRUISE

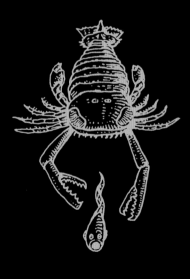

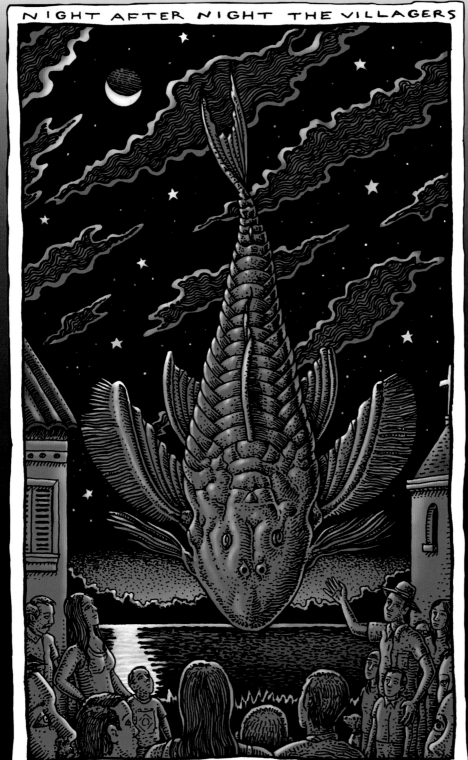

NIGHT AFTER NIGHT THE VILLAGERS

GATHERED AROUND THE MAGIC CATFISH

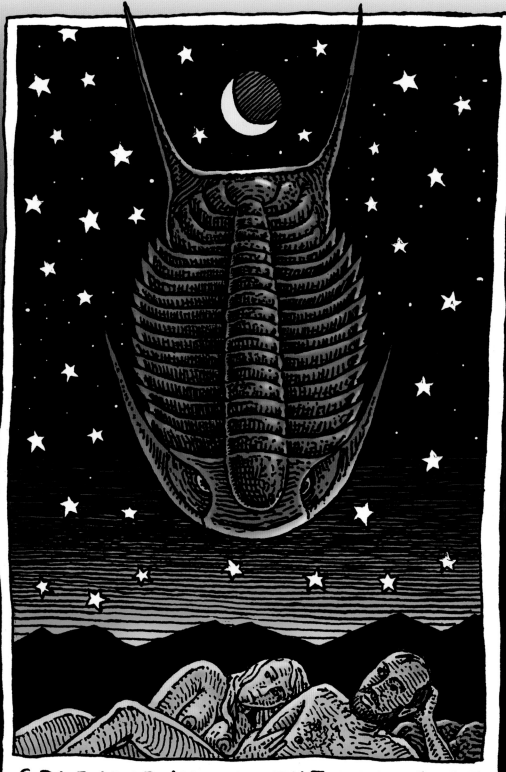

SPLENDOR 'NEATH THE TRILOBITE

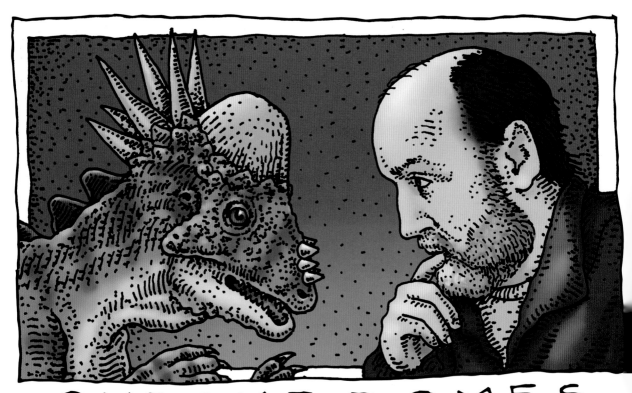

CHROME DOMES

WHERE DOES THE HAIR GO

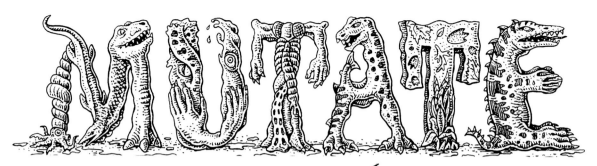

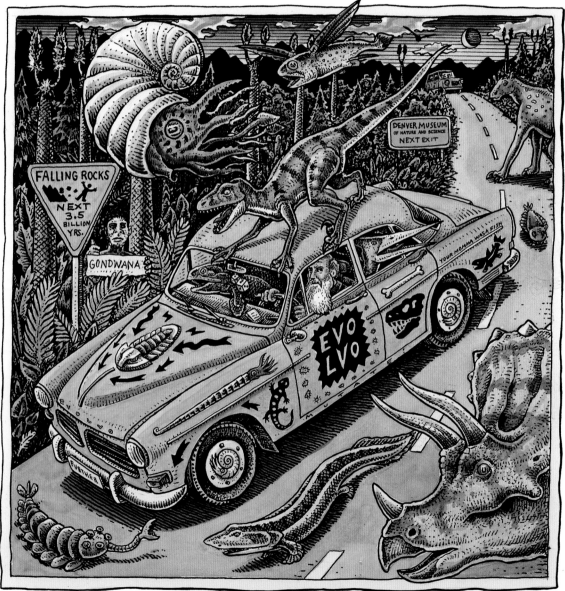

ITS NEVER TOO LATE TO MUTATE

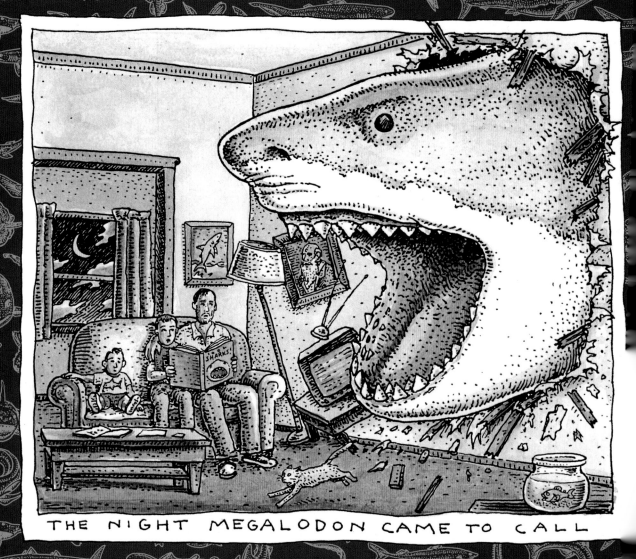

THE NIGHT MEGALODON CAME TO CALL

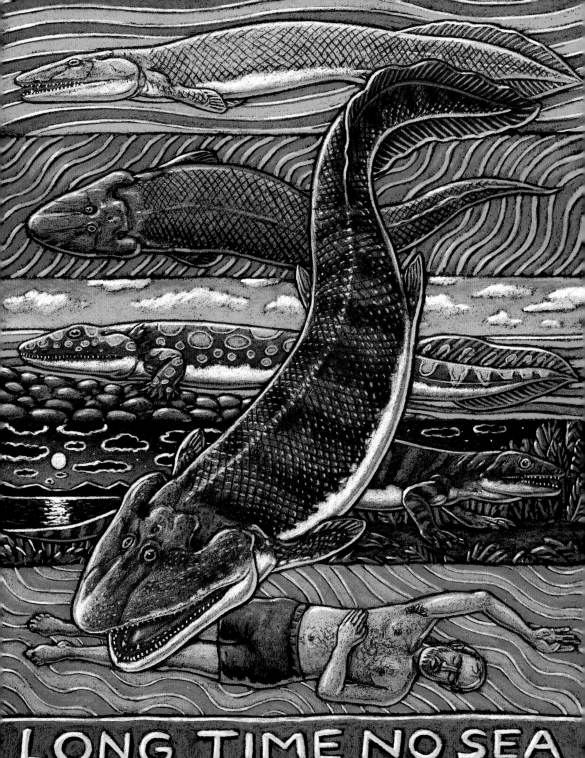

LONG TIME NO SEA

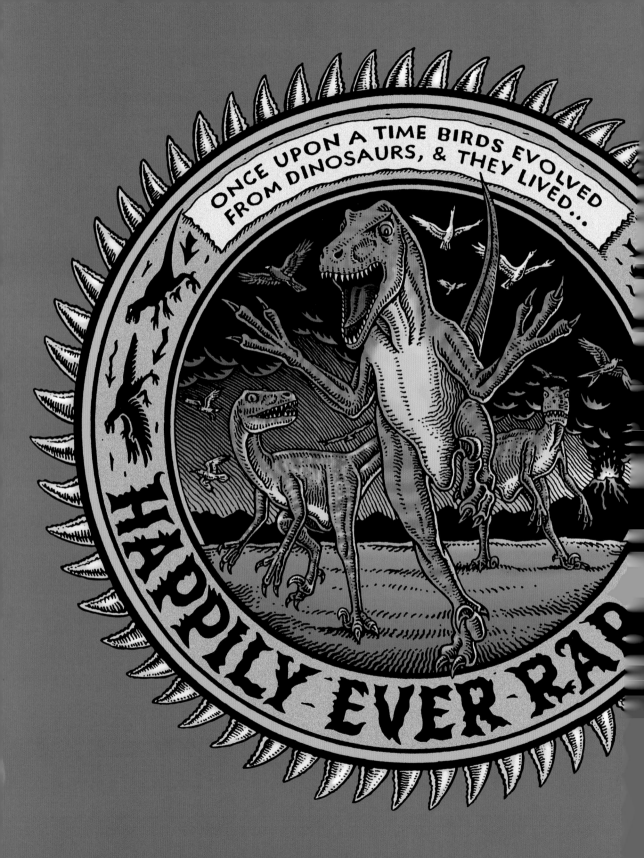

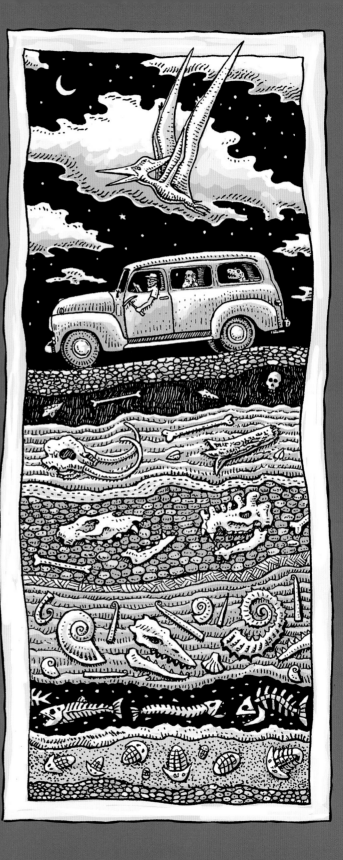

THE DATA IS IN THE STRATA

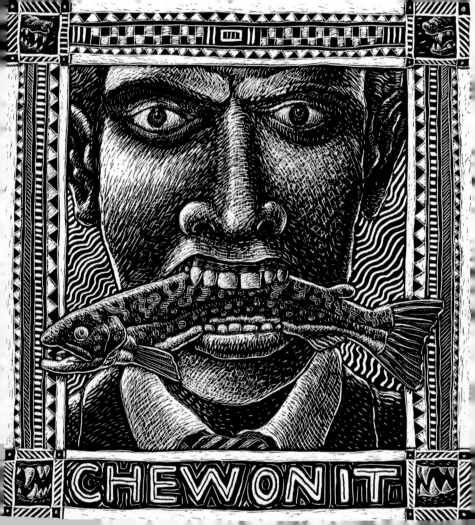

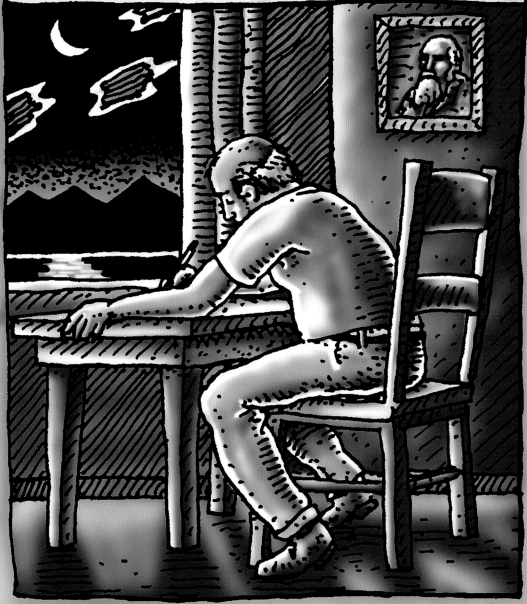

ARTISTS AND WRITERS
ALONE IN THEIR CHAIRS
CHANGING THE WORLD

ONE LINE AT A TIME

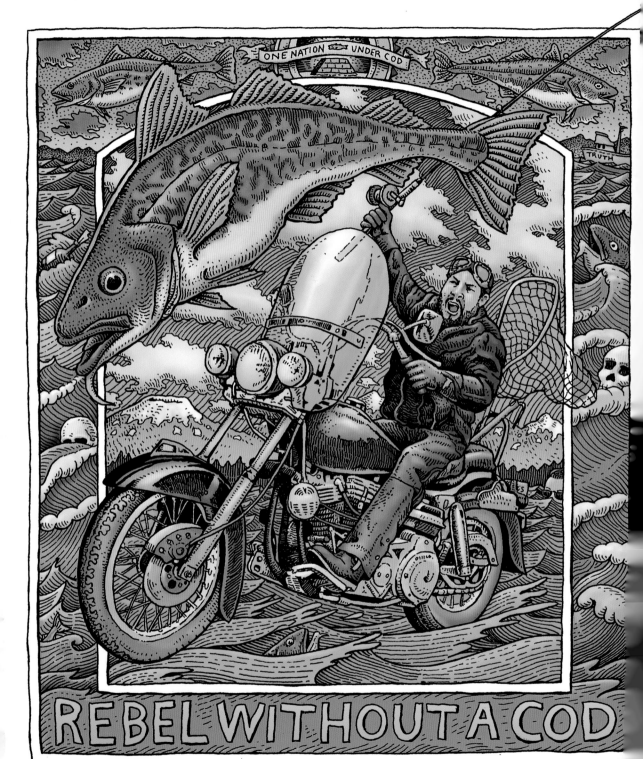

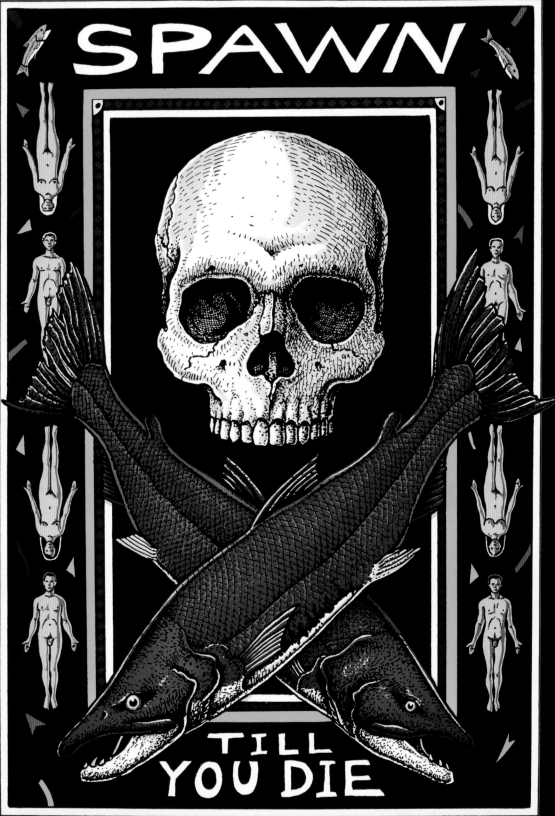

ABOUT THE AUTHOR

Ray Troll moved to Alaska in 1983 to spend a summer helping his big sister Kate start a seafood retail store. The fish store is long gone but Ray is not.

Ray earned a Bachelor of Arts degree from Bethany College in Lindsborg, Kansas, in 1977 and an MFA in studio arts from Washington State University in 1981. In 2006 he was given the Alaska Governor's award for the arts and, in 2007 was given a gold medal for "distinction in the natural history arts" by the Academy of Natural Sciences in Philadelphia. In 2008, he was awarded an honorary doctorate in fine arts from the University of Alaska Southeast.

Troll's unique blend of art and science culminated in his traveling exhibit, "Dancing to the Fossil Record," that opened at the California Academy of Sciences in San Francisco in 1995. The huge exhibit included Ray's original drawings, gigantic fossils, fish tanks, murals, an original soundtrack, a dance floor, an interactive computer installation, and the infamous "Evolvo" art car. In 1997 the exhibit traveled to the Oregon Coast Aquarium in Newport and in 1998 it hit the streets of Philadelphia at the Academy of Natural Sciences. The tour ended in 1999 at the Denver Museum of Nature and Science. By that time it had grown to 14,000 square feet. His next exhibition, "Sharkabet, a Sea of Sharks from A to Z," was shown at the Science Museum of Minnesota, the Anchorage Museum of History and Art, the Alaska State Museum, and the Museum of the Rockies in Bozeman, Montana.

Troll's current traveling exhibit is based on his book with Dr. Kirk Johnson, *Cruisin' the Fossil Freeway*.

He and his wife, Michelle, run the Soho Coho gallery in Ketchikan, appropriately situated in an old historic house of ill repute located on a salmon spawning stream. Ray believes that everyone should be in a band regardless of talent or ambition; his band of musical renegades is called the Ratfish Wranglers.

He has appeared on the Discovery Channel, lectured at Cornell, Harvard, and Yale, shown work at the Smithsonian and has even had a ratfish named after him (a New Zealand species called *Hydrolagus trolli*). Not too bad for a T-shirt—wearing kinda guy.

For more about Ray, check out his website at *www.trollart.com*.